CREATING
MANGA
CHARACTERS

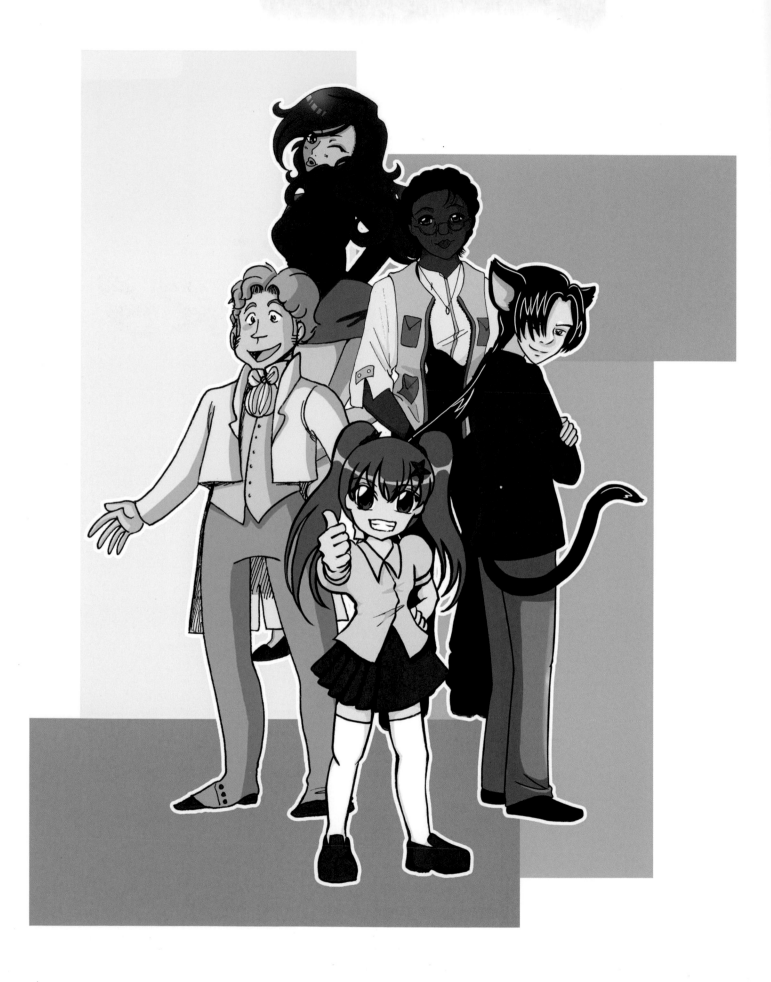

CREATING
MANGA
CHARACTERS

♦ Sweatdrop Studios

THE CROWOOD PRESS

First published in 2012 by
The Crowood Press Ltd
Ramsbury, Marlborough
Wiltshire SN8 2HR

www.crowood.com

British Library Cataloguing-in-Publication Data
A catalogue record for this book is available from the British Library.

ISBN 978 1 84797 381 8

Art and text by Morag Lewis, Rebecca Burgess, Irina Richards, Chloe Citrine and Ruth Keattch. Photography by Sergei and Morag Lewis.

With thanks to Sonia Leong for advice and encouragement, and to Laura Jacques for assistance with proofreading.

Typeset by Simon Loxley.
Printed and bound in Singapore by Craft Print International

CONTENTS

INTRODUCTION

History of Manga

Modern manga as an art form began in the early part of the twentieth century, but its roots date back much earlier than that. In fact, the earliest pictures that appear to show narrative continuity are attributed to a Buddhist priest named Toba Sojo who lived in the eleventh century. His *Animal Caricature* scroll, or *Choju Giga*, is a beautiful example of brush lineart, and is thought to be a satire on the Buddhist clergy of the time. Between then and the present date Japan has a long history of illustrated stories, from the *Otogizoshi* (literally *Companion Tales*), which are a series of short illustrated stories produced in the fourteenth and fifteenth century, to *Kusazoshi* (woodblock printed illustrated stories which covered all age ranges) and *Ukiyo-e* (literally *Pictures of the Floating World*, mass-produced woodblock prints that usually featured landscapes or city scenes), both of which became popular during the *Edo* and early *Meiji* periods (1600–1900).

Despite that rich history of illustrated storytelling, the roots of manga before World War II are hard to define. The word itself can be translated as 'whimsical pictures', which comes from the Chinese characters used to write it in Japanese. It was used to describe *Kusazoshi* and *Ukiyo-e*, but the first person to use the word 'manga' in the context we know today was the artist Yasuji (Rakuten) Kitazawa (1876–1955). He was, in a way, the founder of manga – at least of the word and concept. After the term 'manga' became known, artists like Osamu Tezuka and Machiko Hasegawa were able to produce the artistic styles associated with manga that we all know and love. Tezuka took his initial inspiration from Disney, but developed it in his own way, which just goes to show that inspiration can come from anywhere, and telling stories in pictures really is a global phenomenon.

Nowadays, the words 'manga' and 'anime' and the corresponding graphic style are well known throughout the world. Manga is often referred to as 'those Japanese comics' and it is assumed that most – if not all – manga is full of wide-eyed ninjas, assassins and maids in frilly dresses. In fact, manga is so much more than that.

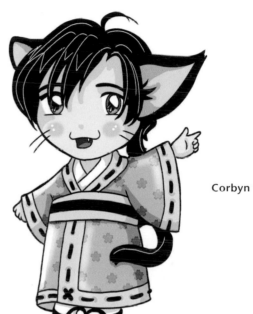

Corbyn the catboy.

Manga is a medium, and thus covers all genres and audiences, from school kids to housewives. Because it is black and white it is cheap to produce in bulk, which means page count is not such an issue in terms of cost (as opposed to the early Western comics, which opted for coloured pages and therefore tried to squeeze as much story onto each page as possible). This in turn means authors have the space to experiment with page and panel layout and the time to go into emotions and thoughts in a pictorial manner. Manga characters are extremely expressive, with high emphasis placed on facial features and gestures. Sometimes it is sufficient just to draw a character's eye or hand to express their feelings and moods.

The art style itself is hard to define. It is true that many manga characters have big eyes and small mouths, but so does Betty Boop, and many manga characters have much more realistically proportioned faces. However, the emphasis on eyes is something that appears to be based on culture; research has shown that, when looking at pictures of faces, Western viewers tend to

focus on the mouth while Japanese viewers focus on the eyes. You can even see this in the 'emoticons' used by each culture; Japanese emoticons put emphasis on the eyes ("^_^") while American emoticons emphasize the mouth (":)"). It has been suggested that this is because emotional control is valued in Japan, but the eyes are harder to control than the mouth, so Japanese people would concentrate on the eyes to gauge emotion. Whatever the reason, the eyes are a particularly expressive part of the manga style, and it is not surprising that they are the feature most picked out by casual viewers.

Nowadays, manga is no longer an exclusively Japanese art form. Many eastern countries have started and succeeded in producing their own versions of manga-style comics. Styles like *manwha* (Korean) and *manhua* (Chinese) have emerged. In the West, many creators have been inspired and influenced by the manga style, just as Tezuka once took inspiration from Disney.

Creating Characters

Although a visual medium, there is no doubt that story is an important factor to manga. And what makes a good story exactly? There are many factors that add up, but one vital factor is most certainly strong characters. Often a story will be of no interest to us if there isn't a great character there to lead us through it.

In Japanese manga, a story's focus on a character is particularly emphasized visually. The popular and distinctive styles we recognize today began with – among others – the artist who is called the 'Godfather' of manga due to his roaring success; Osamu Tezuka. Tezuka purposefully exaggerated the eyes and mouths of his characters so that they could become more likeable and charm readers into following them through a story.

Other areas of Japanese culture take character creation one step further, inventively using the look, personality and setting of a character to create entire franchises. It is not uncommon to find buildings or institutes in Japan that have cute mascots – indeed, Tokyo Tower and Mount Fuji both have cute alter egos! 'Vocaloid' is another great example of this. It is a rather technical computer programme, mainly aimed at professional musicians. But its invention of selling each different 'voice' as an adorable character with a distinct personality has led to a much more charming product. As a result, Vocaloid has reached out to a much wider audience and created everything a great character can offer; from fan-art communities to sell-out concerts.

Whether we find them enchanting, or love to hate them, characters are always what we relate to the most; they are what we remember in a story, manga, comic, video game or franchise. Whole websites are dedicated to single characters from media, wikis are formed to record as much information as possible about beloved characters – from blood types or birth dates to favourite foods and animals. While it is always possible to find similar characters, it is near impossible to find two characters completely alike in physical appearance or personality. Japan's variety in characters is an inspiration to many manga fans, and we hope in this book we can help you create your own inspiring characters!

Tools and Equipment

Before you start creating your characters, let's look at the materials you need to use. The stationery you choose doesn't need to be very specialized or expensive. You don't have to use exactly the same materials that other artists use or recommend – experiment with different brands to compare quality and find out which ones you are most comfortable with. You don't have to use materials any exact way either; sometimes experimenting with techniques and equipment and using them in a way they weren't intended can create some wonderful effects that will complement your artwork.

Workplace

If you are going to make a comic, you will be spending a lot of time at your workstation, so a comfortable, ergonomic set-up is crucial. Choose a place where you are not going to be disturbed. Make sure your chair is of a height so that your feet can rest comfortably on the floor (or a foot rest of some kind will do). Your arms should be able to rest on your table top with your elbows at a right angle. Wrist and arm strain are very difficult for artists to deal with, so it is important to do everything you can to avoid developing these problems in the first place.

It is always better to work with light coming from your 'non-drawing' side (for example light coming from the left if you are right-handed). Plenty of daylight is important, especially if you are working with natural media and colours, but make sure you also have a good bright light to use at night. Ensure that you have enough space to keep all your drawing materials at hand. Some artists will set aside some space for books as well if they are running low on inspiration. Keeping your favourite comics or art books close by can be helpful if you are finding it hard to get into the mood for drawing. Also, keeping some space aside for reference material, such as books on anatomy or colour, or your laptop if you want to look up a reference for a difficult pose can be very helpful. Keeping prior research for a comic or project to hand is also important. When drawing comics you can often forget little details on things such as costumes and settings, so it is important to keep things like character sheets and

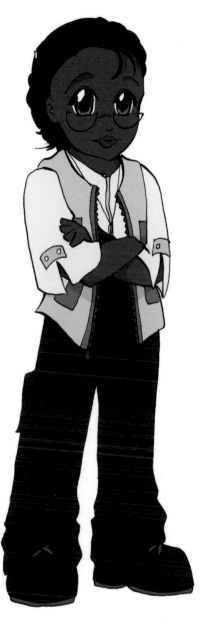

Marre the engineer.

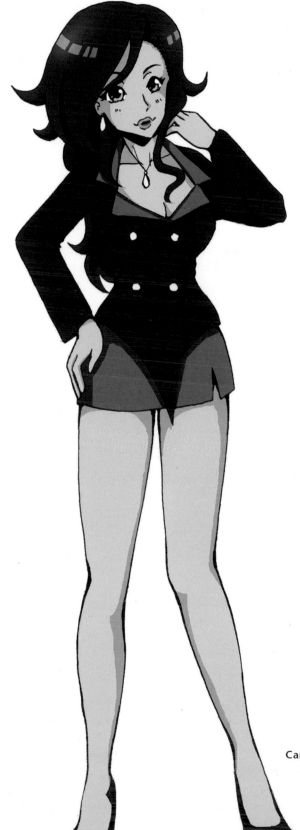

Henry the aristocrat.

Carmel the businesswoman.

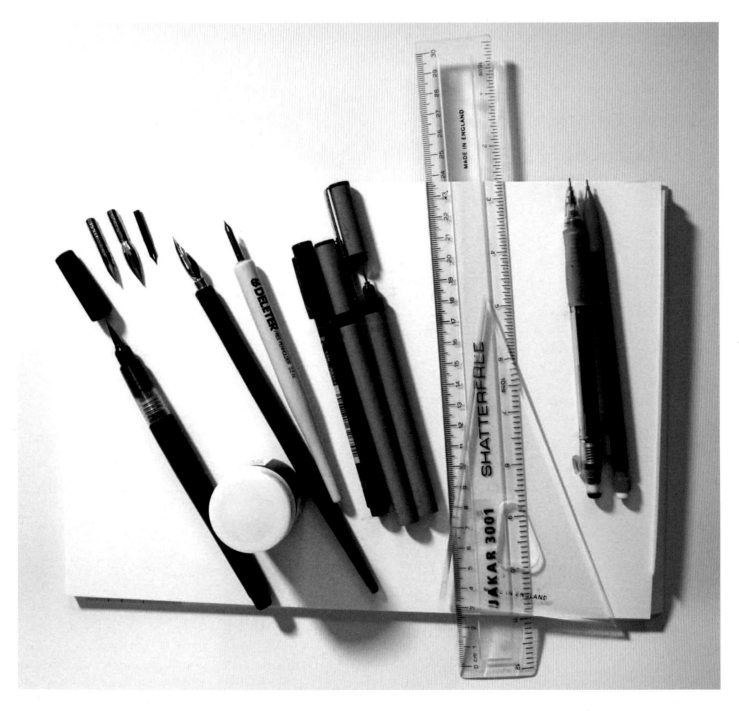

Stationery (left to right): brush pen, dip pen nibs,
dip ink, dip pens, fineliners, ruler and set square,
mechanical pencils. They are resting on smooth heavy
cartridge paper. (Photo: Sergei Lewis)

plans for rooms close to hand. You could keep these in a folder which can allow for more drawing space, or perhaps have a drawing desk set up against a wall, so that you can hang up all those important research images right in front of you. Some artists also like to create 'inspiration boards' when making comics. These are collections of images, colours and notes – anything that helps give you ideas and inspiration for your comic setting, story, artwork and characters. The images are then collaged up on a drawing desk wall, so that you can look to them for ideas, colour schemes or motivation when you are creating your project.

Pencils

Keep a good supply of pencils. Mechanical pencils are good as they don't need sharpening. If you intend to finish your image digitally, there is a technique using coloured pencils that can be very useful. If you pencil out images in coloured pencil, you can ink over the top without having to take the time to rub out the pencil marks underneath, then when you scan in the inked images, the coloured pencil can be removed leaving only the ink. In the past, 'non-photo' (or 'non-print') blue was used, a colour which can't be picked up by the cameras used by professional designers.

Most scanners will pick up any colour you use, but you can either set the threshold high enough so that pale colours are missed, or you can digitally remove the colour. If you decide to use this technique, make sure you choose a coloured pencil that isn't too dark in shade, as darker colours are harder to remove digitally. Also, test out different pencils before using, since some brands can be too waxy, meaning your ink will not show up very well on top of the pencilled art. Pencil and lead choice is a matter of personal preference; some artists like to work with very soft pencils which smudge easily but also rub out easily, while some prefer hard pencils which give a crisp, clear line but which cannot be fully rubbed out.

Erasers

A good-quality eraser is a must. Colourful funky-shaped erasers may be cute, but they won't do the job properly! Make sure the eraser is suited to the type of paper you are using – for example, hard erasers can scrape the surface of rough paper and damage it, and can also damage ink lines. Putty rubbers work by 'absorbing' graphite rather than wearing it away, so last longer than normal rubbers. They are kneadable so can be shaped into forms good for delicate work. However, they can become sticky if too warm, and they aren't good for erasing large areas. It is a good idea to keep your eraser separate from your other art materials,

Choose the stationery that is comfortable for you to use.

especially pencils. Erasers can get dirty very easily when kept with other drawing materials, particularly graphite pencils. This can result in black smudges and marks on your artwork when you're using the eraser.

Rulers

When drawing manga, it is useful to have a straight ruler (make sure it is long enough for the size of your paper – for example, a 30cm ruler is ideal for use with A4 paper) and a set square for drawing panels. Stencils of different shapes, such as ovals, can be a great help for drawing speech bubbles. If you are having trouble keeping your ruled lines parallel with your page, it can be very handy to get a cutting or measuring board to work on top of, because you can use the measures on the board to help keep everything aligned.

Fineliners

Most likely, you will need several fineliners of different thicknesses (for example, 0.3 for fine details and facial features, and 0.5 for inking larger areas). Quick-drying, waterproof fineliners

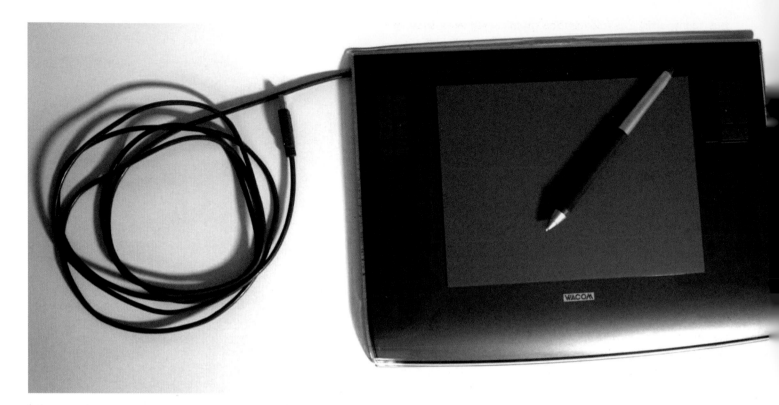

Wacom Intuos 3 graphics tablet. This is one example of many that are suitable for digital artwork. (Photo: Sergei Lewis)

are ideal. Avoid using biros, especially if you create artwork for print; they create scratchy lines, which can look beautiful in a sketch but do not reproduce well. You can also use a thick marker for filling in large black areas such as hair and clothing.

Dip and Brush Pens

Dip and brush pens are a non-messy way to create more 'flowing' lines. Dip pens are like fountain pens in that they use flowing ink through a nib, but instead of having a replaceable cartridge, they are used with a bottle of ink (which they are dipped into, hence the name). Nibs are pliable and so can give good line width variation, although they have their limits. A variety of nibs can be useful for very broad lines and fine details. Bear in mind that nibs do wear out, so you will need to maintain a steady supply.

Brush pens are pens with brush tips. They are less messy than actual brushes and more flexible even than dip pens, although they can be hard to control on the finer lines. They can also be used for colouring.

Markers

Many artists colour their work using special marker pens. The two most common varieties are Copic and Letraset. These markers come with a variety of nibs, such as broad, fine or brush, and give an even, smooth colour with a light watercolour effect. You can layer the colours, or blend them together. There are a few drawbacks; most markers are alcohol-based, so if you use them to colour an image you will have to draw in pencil, or choose alcohol-proof ink or fineliners. Also, marker colours easily seep through thin paper, so heavier paper or special marker paper work best.

Screentones

Have you seen those 'patterns' on manga pages? They are called screentones and are used to accentuate and emphasize the narration. There is a great variety of screentones, from simple dots that can be used as shadows, to swirly, sparkly and feathery ornaments to indicate mood and atmosphere. Traditional screentones are cut into the required shape and pasted onto a manga page. However, many artists use digital screentones as they are much easier (and cheaper!). Digital screentones are available for commonly used art programs such as Photoshop,

but many artists use screentone-specific programs such as Manga Studio, an affordable program with a lot of tone choice.

Digital Sketching And Inking

Graphic programs such as Photoshop and Manga Studio can be used to create and edit artwork. It is entirely up to you how much of your artwork you do on the computer, if any. Some artists draw all their art digitally from scratch. Others prefer to sketch and plan on paper, then do the correction, inking and finishing digitally. Some prefer to ink by hand, but tone on the computer, and so on. If you do any digital work at all, a graphics tablet is an essential tool to create professional-looking art. Graphics tablets are electronic tools consisting of a flat surface and a pen-like stylus. They usually connect to your computer via a USB port, and the computer picks up what the stylus does when touching the surface – in its simplest use, a graphics tablet is a mouse in the form of a pen. However, good-quality tablets are capable of pressure-sensitivity, and most art programs will detect this, which means you can use a graphics tablet like a dip pen, varying your line width with pressure.

Digital drawing can seem daunting at first, and it takes a bit of time to develop this new skill. However, once you have got used to it, digital drawing becomes second nature and you'll be looking for the 'undo' button on your pencil!

Paper Options

The type of paper you use depends on the purpose of the art you create, your chosen medium, and the materials you are

Whatever your choice of materials, practice makes perfect.

going to use. Ordinary A4 cartridge printer paper is good for producing sketches that are going to be finished digitally, or for black and white linearts or artwork using fineliners. However, if you are using dip pens, you may prefer heavy smooth cartridge paper or Bristol board; cheap printer paper tends to let ink 'bleed', spreading out a little from the line you have drawn. If you are colouring your artwork using alcohol-based markers, it is better to use marker paper (and alcohol-proof ink!). You can also buy pads of special manga paper, which is bleedproof and heavy enough for both colouring work and creating black and white manga pages.

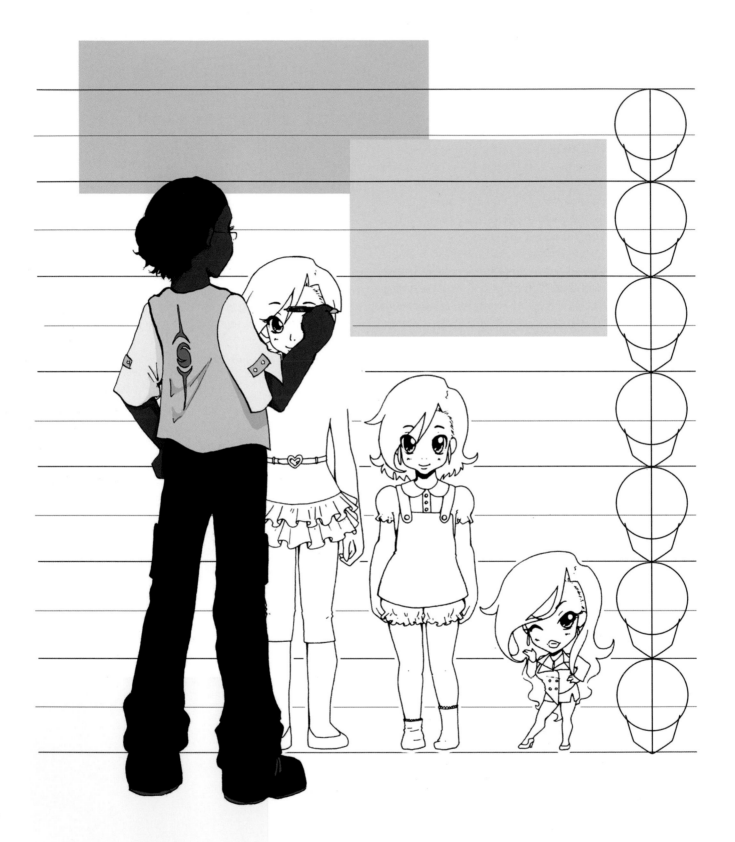

ANATOMY AND PERSPECTIVE

The human body obeys certain rules of proportion, which we know instinctively but often don't think about. The manga style can be deceptive in that some rules are clearly broken (for example, eye size relative to head size), but in fact most are maintained even in the more exaggerated styles. Obviously the choice of which rules to stretch (and how far) is up to the individual, but knowing the rules first is essential to keep your characters looking convincing.

Here is a quick introduction to drawing in the manga style and the rules of proportion that will help keep your characters believable whatever you choose to do with them.

Head-to-body Ratios

If you are struggling with perspective, or have noticed that different manga styles seem to use different proportions, you have inadvertently stumbled upon the Head-to-Body ratio. Simply put, this ratio dictates how many 'heads' will fit into the height of the character (for example, a 1:8 ratio means that for one body, there will be eight head heights, including the head itself).

The smaller the ratio, the more deformed and *chibi*-like the character will be. However, do not assume that a higher ratio will make them look more defined and adult; as you can see with the 1:10 ratio, there is a limit to this approach.

Different manga genres vary the number of heads their characters have for effect. *Shojo* manga style is usually more realistic,

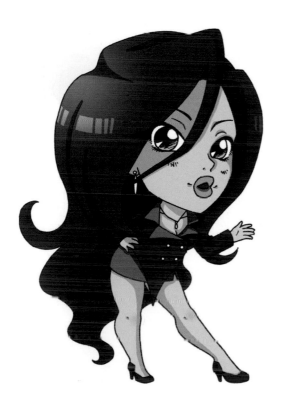

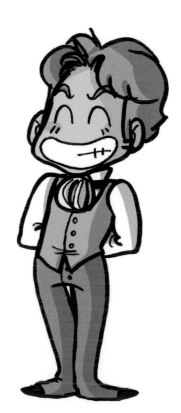

LEFT: **Breaking the rules of proportion can be very effective.**

RIGHT:
However, it's necessary to know the rules before you break them.

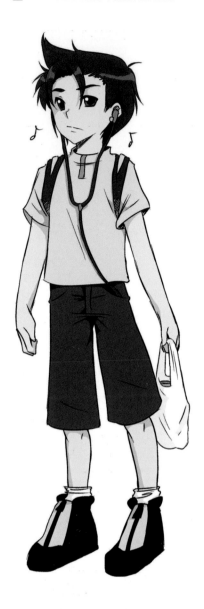

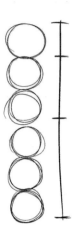

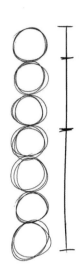

Examples of different head ratios: a boy who is six heads high, and a girl seven heads high.

and will use the larger ratios over the smaller. In certain *shojo* manga, figures are drawn very tall (especially the handsome, male love interests!); up to nine heads high. These tall, thin figures help give *shojo* manga its graceful and delicate look.

In *shonen* manga the characters are often drawn younger, so they aren't as many heads high, giving the characters a sturdier and more solid feel to them. A typical *shonen* manga style will use from ratio 1:4 up to 1:7. Head ratios of 1:3 and under are usually only used for mascot characters, or to portray a comical scene. The proportions of *chibi*, or super-deformed

If in doubt, try the 1:6 head ratio. Then experiment!

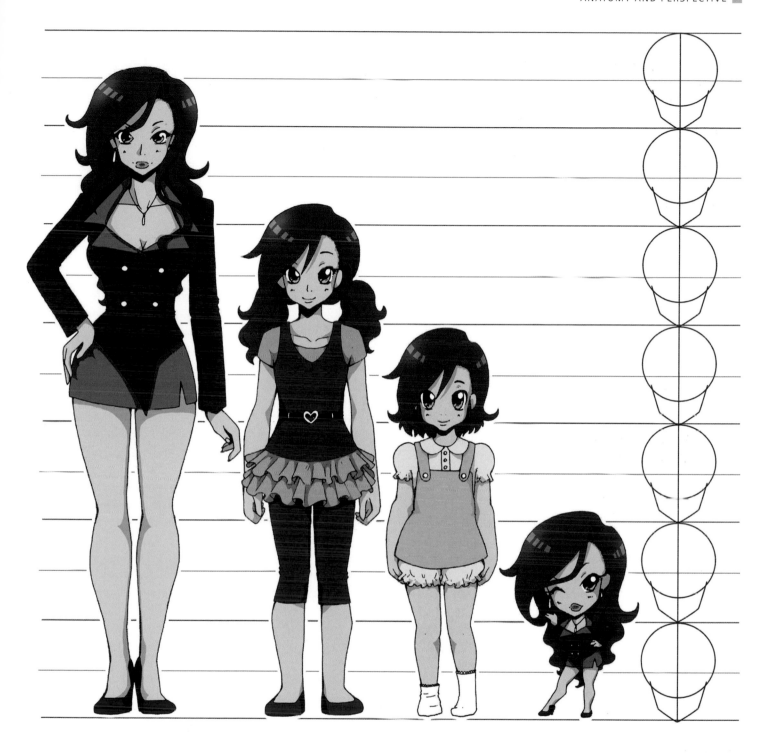

style characters are even more extreme. Many *chibi* figures are only two heads high with their whole body fitting into just one head length!

If in doubt over which ratio to use, a good all-rounder to adhere to is the 1:6 ratio. It can be used in most manga styles, and will not look out of place!

Using the length of the head as a guide you can draw characters of different ages. In proportion to their body, children have much larger heads than adults. A baby can be only three

Different ages and styles need different head ratios: From left to right: adult, teenager, child and *chibi* forms.

heads tall, whereas an average adult is six or seven heads tall. Younger children are about three to five heads tall, and teenagers perhaps five or six heads tall. As a person gets older, their head takes up less and less of the total height of their body. By keeping this in mind you'll be able to effectively draw characters of any age.

17

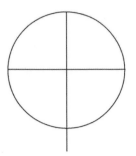
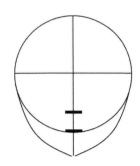
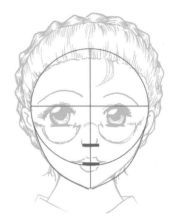

Basic construction lines for a face.

Drawing the Head

The face is usually the focal point of a picture, the first thing most people will look at. The same is true of a comic page panel; faces draw the reader's attention and their expressions often speak to what is going on before any dialogue is read. Obviously there has to be a body, and when you think of a character you should have an overall idea of their appearance – and their body has to match their face! But it is worth spending a lot of time on each character's face, because this is what readers will look to for your character's expressions and dialogue. An expressionless character is not a convincing one. So – where do you start when drawing a face?

Think in halves when sketching out a face from the front perspective; faces are usually bilaterally symmetric. Start with a simple circle. Divide this circle in half horizontally and vertically, and extend the vertical line down beyond the bottom of the circle. Starting from where the horizontal line intersects the circle and ending at the bottom of the vertical line, draw a rough chin shape. Divide the distance between the horizontal line and the chin in half to mark where the nose is, and then divide space between nose and chin in half again to mark the mouth position. The top of the eyes is about level with the horizontal line; the eyes themselves should be approximately halfway between the top of the head and the chin. How far you extend the vertical chin line is up to you; obviously a longer line makes for a longer face, and short *chibi* faces require shorter lines.

The hair volume can (and often will) extend very far from the face – do not be afraid to experiment! Drawing the circle first, before adding features, means you can accurately gauge where the hair starts. If you don't draw the circle that indicates where the top of the head is, you risk your character developing 'flat head syndrome'.

As long as you can keep these proportions in mind, you should never run into problems when sketching out a new character!

When drawing the same face from the side ('in profile'), take the proportions of the previous face. Using it as a reference, draw lines indicating the head size, and where the eyes, ears, mouth and nose are positioned so that you can ensure continuity is kept. You can erase these lines once you are finished.

A common mistake that is often made when drawing the side view of the face is drawing the eyes too close to the bridge of the nose. Do you remember that in front view, the distance between the eyes is equal to one eye? As the side view is technically 'half a face', this distance will be halved, and measured from the bridge of the nose to the eye. Bear in mind the shape of the eye; from the side, eyes are triangular, with the acute angle pointing to the back of the head.

Another easy mistake to make is the positioning of the ears. You know what height and size to make them from where the eyebrows and nose are, but it's easy to put them too close to the front of the face. Take the distance from the front of the face to the back of the head; the ears lie approximately one third of that distance from the back of the head.

FACIAL PROPORTIONS

When placing the eyes, there should be a distance of one eye in between them (the 'third eye'). The ears always lie in the space between the eyes and nose, with the tips of the ears at the same level as the eyebrows, and the lobes roughly level with the bottom of the nose. The ends of the mouth are roughly in line with the inner corners of the eye, although if your character has a large or a small mouth, that will change. The neck is roughly in line with the outer corners of the eyes. These little tricks will keep your characters looking consistent and believable.

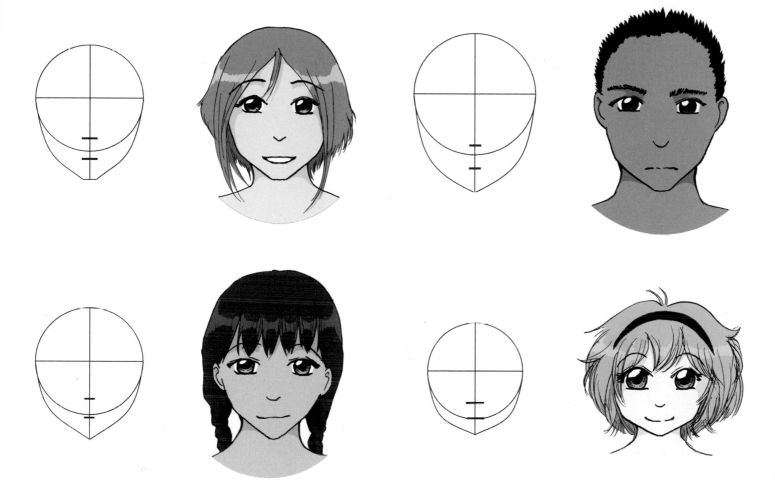

These construction lines work for any facial shape.

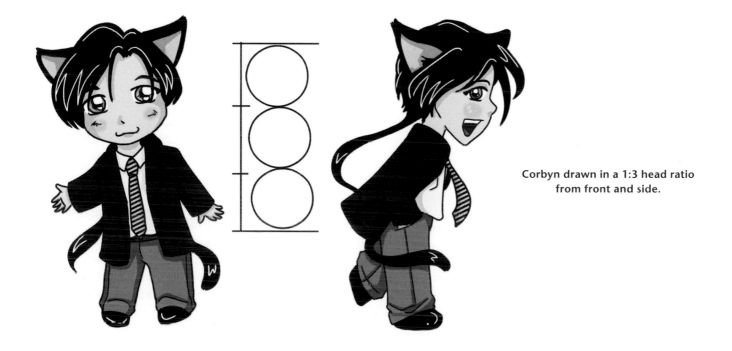

Corbyn drawn in a 1:3 head ratio
from front and side.

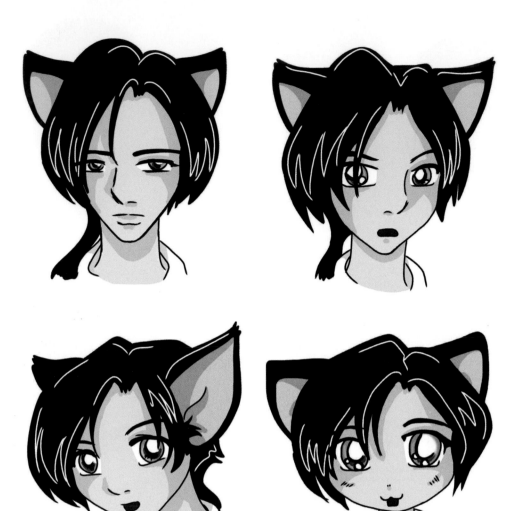

The rounder the face (and by implication, the lower the head-to-body ratio), the more child-like Corbyn looks.

You may have also noticed that the higher the head-to-body ratio, the more defined the face shape and the more adult the face appears. This is because older characters require higher head-to-body ratios, and younger characters will use lower ratios. This means that the smaller the ratio you choose, the rounder the face needs to appear; it helps to give the impression of cuteness and youth. This doesn't mean an older character can't be rendered in *chibi* form, but in general, the smaller the head-to-body ratio, the rounder the face, and the younger the character will look.

The Head in Space

Now that you've grasped how to sketch out the facial proportions, it is time to envision the head in space. When you draw a character in a simple 'head on' or profile view, it makes them look flat and stiff, and emphasizes that they are two-dimension-

al. It can make them seem as if they have just been put 'on top' of the surrounding background. You want to give the impression that the character's face and head occupy an area or space; a floating head. Even though they are only 2D, you need to imagine them as though they are 3D – as when the character is in your story, they will occupy an entire world! By drawing characters at different angles, you give the illusion that they are in a 3D space or area, and they become more in place within their surrounding background. Doing this will also help your characters look much more animated and engaging. Look at people around you – do they always stand up perfectly straight, in profile or facing you? Or are they moving their heads and bodies from one odd angle to the next? By learning how to draw the head at different angles, you will be able to create the illusion of a 3D space around it that makes it seem more real and animated. Using the proportional and construction rules you have already learned, you can change the orientation of the head to view the character from multiple angles.

Take a three-quarters view to start with, where the character

Using construction lines means you can reproduce the same face consistently at whatever angle you want.

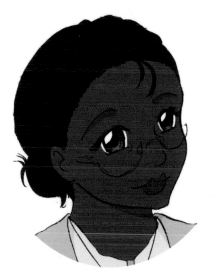
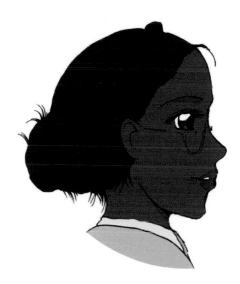
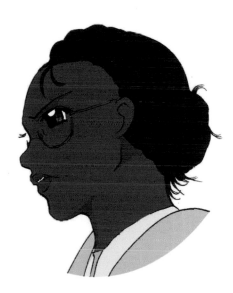

Marre's face at different angles.

is looking to the side but is not in full profile. You will still need the circle for the main part of the head, and the horizontal line is the same as before, but now the vertical line bulges out to the side as the head is turned – imagine you have drawn a line down a tennis ball and then rotated the tennis ball around its vertical

KEEP IT SIMPLE

When doing this exercise, you do not always have to draw in all of the features. Instead, you can add a simple cross-hatch on the face to indicate where the eyes, nose and mouth would be located. At this point, this will be sufficient, plus it will save you time, too! There is always time to go back later and add details if you want to.

axis. This means your chin lines will come not from the side of the circle but from partway along the horizontal line. The rest you should be able to fill in just as before; divide the vertical line into two between the horizontal line and chin to mark the position of the nose, and then into two again between nose and chin for the mouth. Remember that the eye furthest from you will be slightly smaller than the nearer eye, and depending on how far the head is turned, the nose may obscure part of the further eye. The ears lie roughly where the jawline stops (feel your own jawline) so in these simple layouts, the line that you draw from horizontal line to chin will mark where the ears are. Remember that they reach from eyebrows to nose, and that, when viewed in profile, they are one third of the distance from the back of the head to the midline of the face.

Now imagine your three-quarter head looking slightly up or slightly down as well. The horizontal line becomes a circle around your ball – which of course it always was. You can see In the examples how the rest of the features move accordingly, but the general rules remain the same.

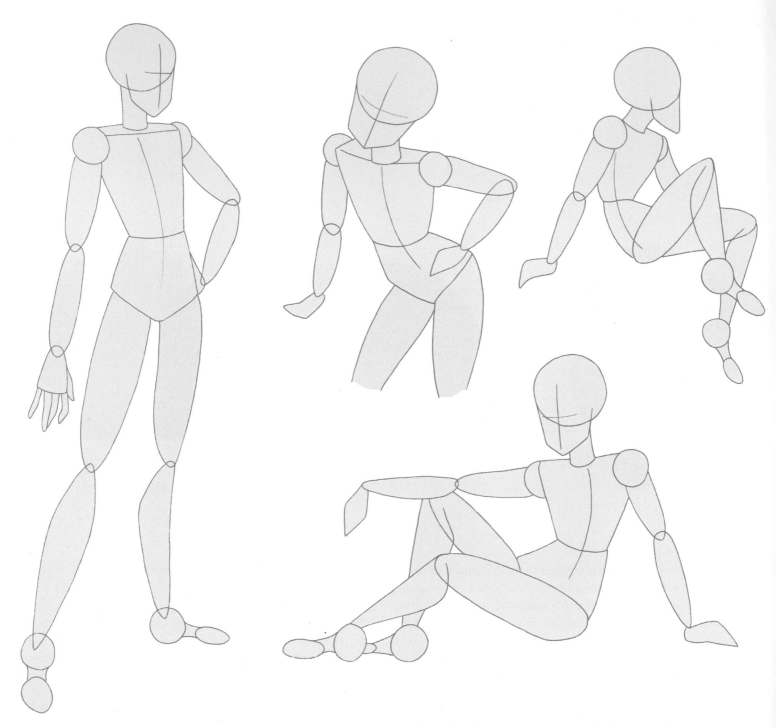

Remembering the anatomical rules of thumb will
ensure your characters remain in proportion
whatever pose they adopt.

Proportions

Like the face, the body adheres to a number of fixed rules regarding its proportions. Because every person is different, these rules are not 100 per cent accurate and will vary from person to person, but on average they hold true to human proportions. Even in some of the most extreme manga styles, where proportions are stretched to their limits, these rules are followed in order to make the characters look natural and anatomically correct.

When the arm is hanging down by the side, the elbow falls at the midpoint of the torso in line with the belly button, and the hand reaches to the middle of the thigh. From the wrist to the tip of the index finger, the hand is one head length long – the foot is also a head length long! The shoulders are usually around three head widths wide, depending on the gender and build of the character. Hands are big enough to cover the face if spread out (not the entire head!). If you look at yourself in the mirror or at some photographs of people, you'll be able to see these body proportions in action! Knowing these proportions will help you draw the body from different angles and in different poses.

Fleshing Out

A good way of creating a complex pose is to do a rough sketch of the 'dummy figure' first before fleshing out. This helps iron out possible mistakes. At this stage, use light pencil strokes that you can easily erase later. There's no need to worry about small details such as fingers too much at this stage. Do not rush it – drawing an anatomically perfect character on the first try is a difficult skill even for experienced artists! Pay particular attention to the measurements that have been discussed above, but bear in mind that they may look slightly distorted depending on the pose. For example, when drawing a person running towards the viewer, one leg is closer to us and therefore looks longer than the other. Similarly, a raised fist would look disproportionally large. This is called 'foreshortening' (see Chapter 2).

Once you're happy with the 'skeleton' of the pose, you can start adding details such as outlines of the head and limbs, fingers, toes, and facial features. The use of reference is extremely helpful for practising difficult poses and details. Find pictures on the Internet or in magazines, take your own photos or better still, draw from life! Ask your friends to pose for you or draw quick sketches of passers-by when you're out. Using a posable artist's dummy can also help, as it breaks the human body into simple shapes (these are easily available in art shops).

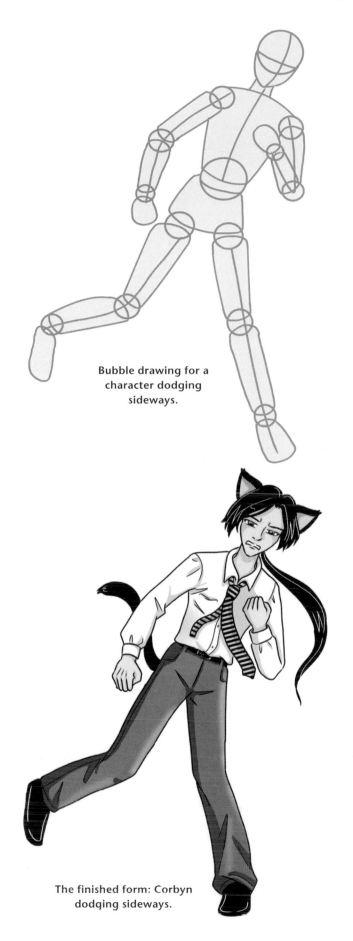

Bubble drawing for a character dodging sideways.

The finished form: Corbyn dodging sideways.

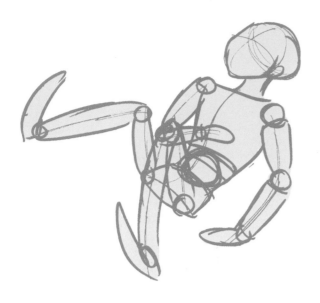

Bubble form for a character laughing uproariously.

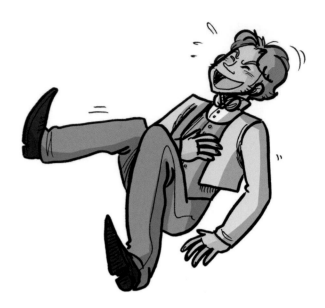

The finished form: Henry, laughing.

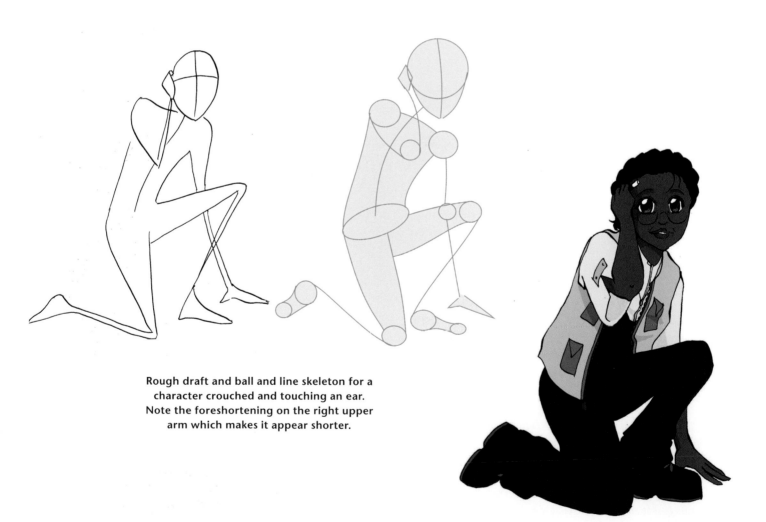

Rough draft and ball and line skeleton for a
character crouched and touching an ear.
Note the foreshortening on the right upper
arm which makes it appear shorter.

The finished form: Marre, crouched and putting her
pencil back behind her ear.

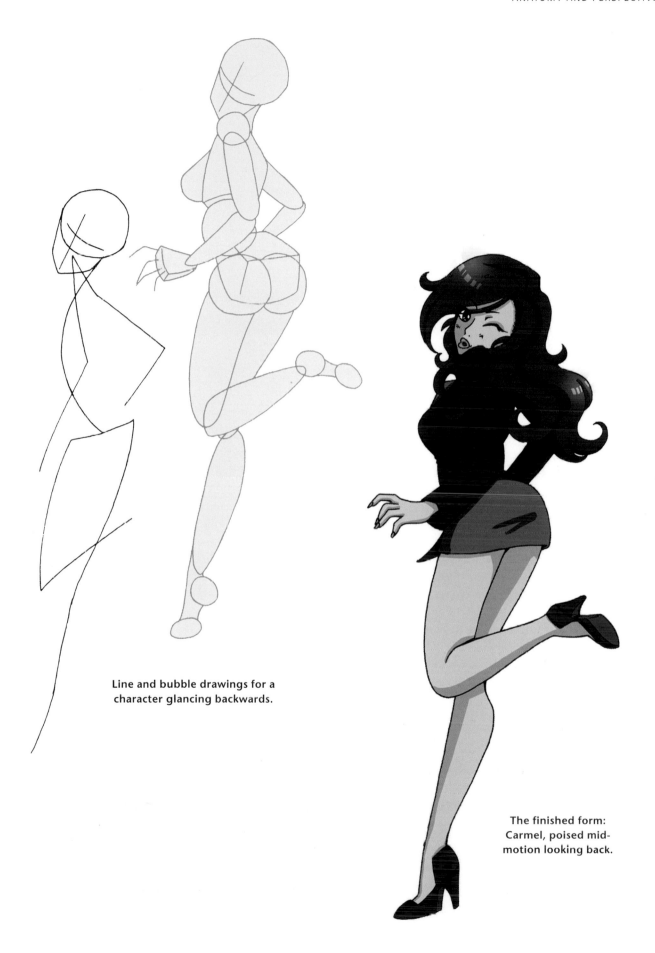

Line and bubble drawings for a
character glancing backwards.

The finished form:
Carmel, poised mid-
motion looking back.

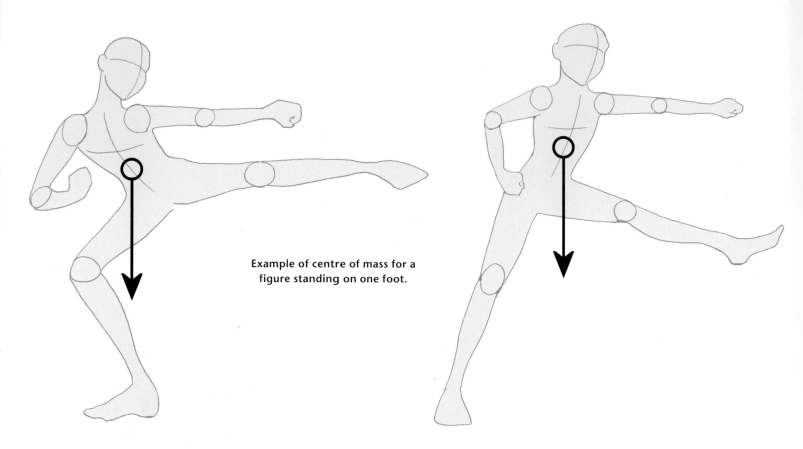

Example of centre of mass for a figure standing on one foot.

Balance and the Centre of Mass

When you draw a figure – especially if the pose is an unusual one – take care that the body is balanced so that it doesn't look as though it is about to fall over. The centre of mass (or gravity) of the human body is in the torso. It can be helpful to draw a line from this straight down, and see how your character is positioned in relation to that line. Is there adequate support for the body? If your character is supported by a single hand or foot, then the line from the centre of mass must pass through or near that point of support. In the example, the centre of mass of the figure on the left is well supported by the right foot. The pose of the figure on the right is similar, but the centre of mass is not supported. To balance this figure the left foot would have to be lowered to the ground, or the centre of mass (the torso) moved over the right foot.

The first example is very obvious, but it's not always so easy to work out what is wrong. It can be helpful to think about the balance of the body, especially if there is only a single point of support. Keeping the centre of mass directly above the point of support isn't always enough; the figure must also be balanced. If there is roughly the same mass on either side of the support, then the figure is balanced. In the example above the figure on the left is balanced, but the figure on the right is unbalanced; with both legs to one side. In real life the figure on the right would fall over. Bear in mind that a leg extended to one side

will balance more mass on the other side than it would if it was tucked in.

Of course, balance is much less of a worry if both feet are on the floor, although it is still possible to look unbalanced while standing on two feet! As always, if you're really not sure, try standing in the pose yourself and see if you feel stable. Even if you can hold the pose, if it's not comfortable for you it probably won't look comfortable for your character either.

COMMON MISTAKES AND HOW TO AVOID THEM

Remember to flip your picture regularly so you are looking at a mirror image. This will help you to iron out any mistakes, maintain symmetry, and prevent your image from ending up lopsided.

Check your own hands and feet for reference – for example, to see which way the toes are pointing.

Try adopting the pose you are drawing to see if it's possible – it's surprisingly easy to draw a pose that is anatomically implausible.

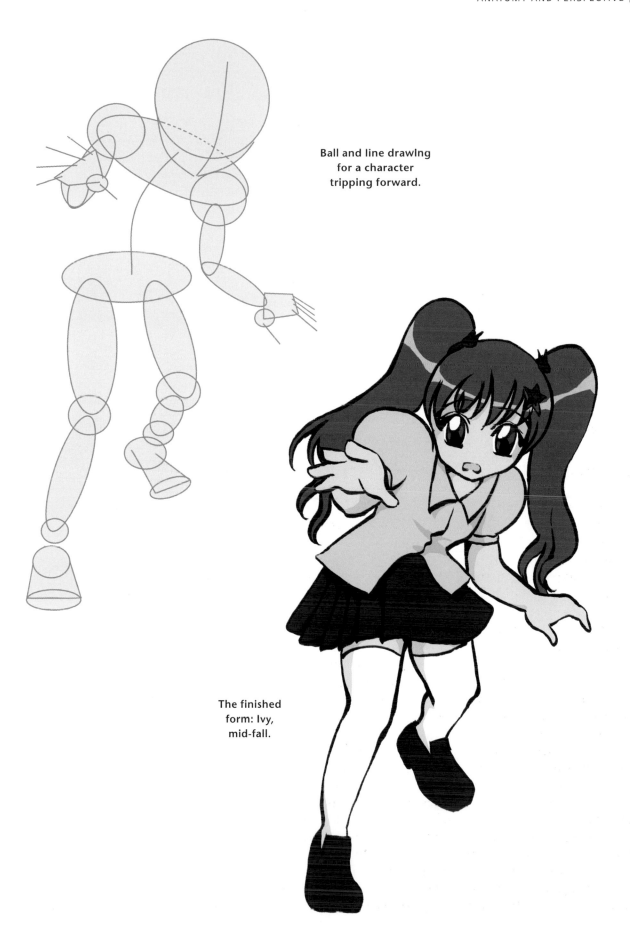

Ball and line drawlng
for a character
tripping forward.

The finished
form: Ivy,
mid-fall.

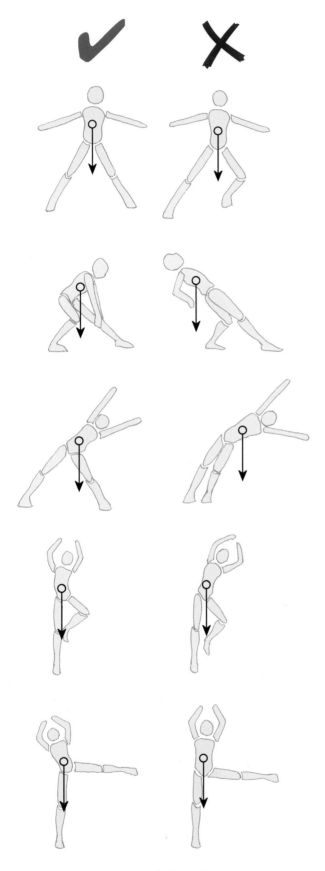

Examples of correctly (left) and incorrectly (right) balanced figures.

THE KNEE BONE IS CONNECTED TO THE THIGH BONE...

Because this is only a brief introduction to how to draw the human figure, we have not gone into the details of the bones, muscles and joints that structure the body. Obviously anatomy is extremely important; it defines body shape and structure and limits what is possible in terms of poses and motion. Consider joints; your knee is a hinge joint and only bends back and forth – and has a limit to how far it will bend, too. Your elbow is the same. Your hips and shoulders, on the other hand, are ball-and-socket joints, and are much more flexible. You should be able to rotate your arms in a 360° circle; try that with your knee and you will end up dislocating it. Muscles are just as important for the finished form; you can't draw a muscular man without knowing where the muscle bulges should be, unless you have a convenient strong man to pose for you on demand.

Knowing the basics of human anatomy is very useful for drawing figures, and there are several good textbooks that will help you appreciate anatomy as used in art. Life drawing is also excellent training if you want to be able to draw people, even when your intended style is a fairly unrealistic one, which some manga styles are. But even simple observations on your own body should tell you if something you have drawn is anatomically impossible for a human to do.

Hand Anatomy

It is important to draw hands accurately, but it is a skill that requires lots of practice! A quick and basic way of constructing a hand is to first draw a rounded shape for the palm. Draw a cross through it, making the vertical line double the height of the palm; the vertical line will become the middle finger. Add four more lines, starting from the vertical line at the base of the palm – the other fingers. The index finger and the ring finger are both shorter than the middle finger. The small finger is about two-thirds of the ring finger's height. For the thumb, draw a line out from the base and don't forget its extra bulge of joint and muscle at that side of the palm. When pressed to the side of the palm, the thumb reaches the base of the index finger. Finally, divide each finger into three parts (these are called phalanges) and the thumb into two.

It helps to look at your own hands and practise drawing them

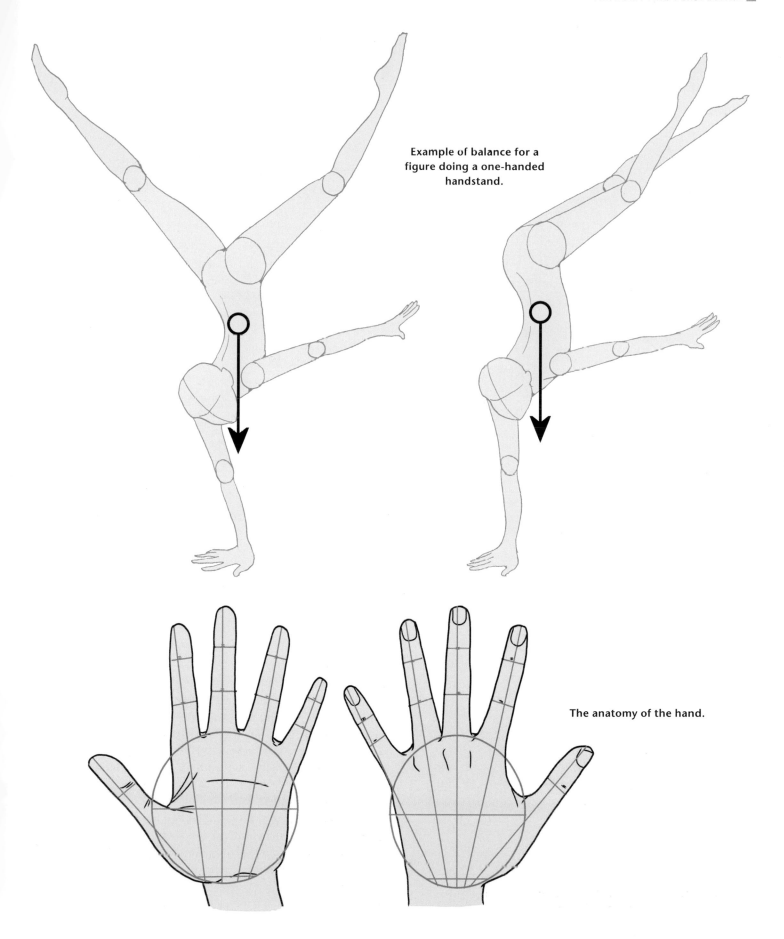

Example of balance for a figure doing a one-handed handstand.

The anatomy of the hand.

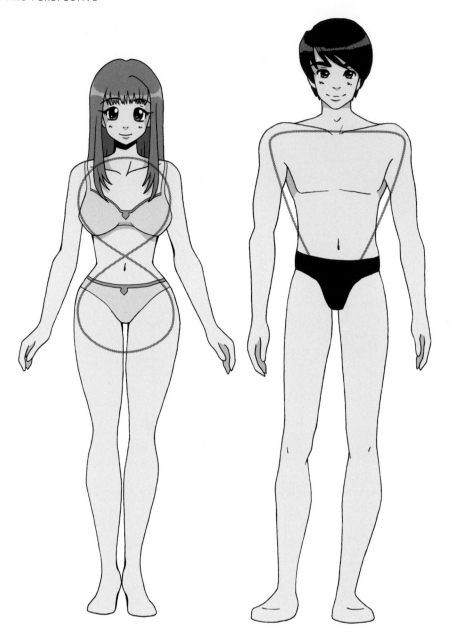

Gender makes a difference to body shape and proportions.

– a lot! With the hand gestures that are most difficult to draw, take photographs of your own hands and use them as references.

Gender and Age Differences

Now that you have understood some simple approaches to perspective, it is time to show you how these rules can be distorted. Once you know the basics of human proportions you can begin to draw in some of the more subtle body variations between different genders and ages.

Starting with the face, typically males have a more angular jawline, larger eyebrows, a more pronounced brow bone and longer, larger noses. Whereas females generally have larger eyes and lips, a smaller nose and a softer face shape with a more

pointed chin. These are sweeping statements – of course women can have large noses and men can have pointed chins. But when drawing characters like this be sure to put in some of the typical features of their gender to reduce confusion. You can draw a female character with a larger nose, but if she has full lips and large eyes she will still look feminine.

The body shape of a character can help show clearly what gender your character is. Women have narrower shoulders, a thinner waist and wider hips. Often the width of the hips is equal to (or sometimes bigger) than the shoulders, giving her a body shape like a figure eight. A man will often have the typical 'V' shape to his body, where his shoulders are wide and his hips are narrow. Depending on how much muscle mass he has, the shape of this V becomes more or less pronounced. An adult man who does a lot of training will have more muscle on his shoulders, giving his body shape a V with a wider top. Adult men and

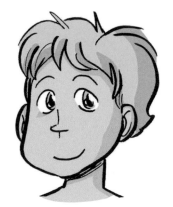
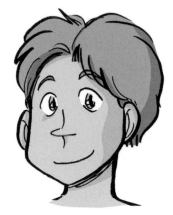
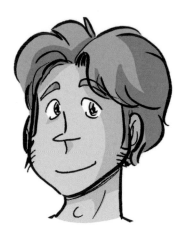

Faces change shape and proportion as they age.

juveniles who have less muscle will have narrower shoulders, giving their bodies more of a box-like shape than a V.

In reality, until they reach puberty, the body shapes of boys and girls are a relatively similar box shape. There are some differences; in general males of all ages have larger hands and feet and slightly longer torsos than females.

As a person gets older other parts of their body also change. The hands are a good example; the palms of babies' hands are very large and the fingers short and chubby. As a person gets older, the fingers get longer in proportion to the whole hand, until adulthood when the fingers are as long as the palm itself.

The proportions of faces also change. In babies and children the eyes are larger and are often located lower on the face. As a person grows older their nose becomes longer – in fact, your nose and ears never stop growing! One pitfall people fall into when drawing older characters is to just draw an adult as usual and simply add some wrinkles. This may work for characters who are around middle age, but your character will never really look very elderly this way. Draw the nose and ears larger and remember that skin loses elasticity with age, so it begins to sag down off the bones of the face. The body may also change as a person gets older, as often people get a little shorter as they get

BODY TYPES

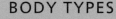

Age and gender are very important in determining your character's build and body shape, but they are not the only factors. A lumberjack will have a very different build from a lanky athlete of the same age. The more heavy physical work the character does, either as part of his or her job or as a hobby, the bulkier their muscles will be, leading to broader shoulders and a deeper chest (particularly in men). On the other hand, someone who runs a lot will have a leaner build while still being strong and fit. A couch potato won't necessarily be overweight, but will not have the muscle tone of the bodybuilder or the athlete. This is as true of women as it is of men.

Of course, when considering women, there are other body differences to consider including size of chest, waist and hips. It may be tempting to model your female characters after a Barbie doll, but if their proportions are too unlikely you will end up alienating readers. A woman with a tiny waist will not have a very wide bust or hips. If your character is slender, she will be slender all over. Look at your character in profile. If she looks top-heavy, as if she's about to tip over, you need to do some adjustments.

older – this is sometimes the result of their back becoming hunched or their legs being bent. Applying these observations to your drawings will make your elderly characters a lot more convincing.

When fleshing out your character, keeping these age-related quirks in mind is important, as you will need your audience to be able to identify your character's age.

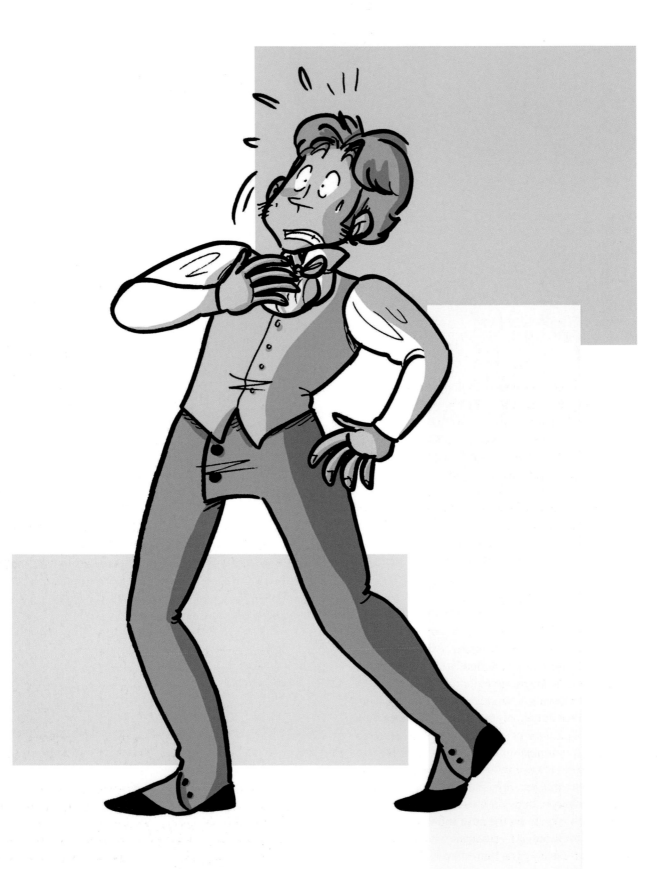

CREATING EXPRESSION

Now you know how to draw the character's face and body, the next step is to make it animated and expressive. Your character's facial expressions, poses and gestures are an important part of narration; they can tell a story without using words. Manga is a very dynamic (and often action-driven) art form. Facial features in manga are often exaggerated, or on the contrary, simplified – but still convey a wide range of emotions. On the example below you can see how adding one facial feature at a time changes the character's expression.

Think of your character's personality. Is it laid-back or explosive? Good-natured or devious? Shy or daring? What situations do the characters find themselves in? Based on this, practise drawing their most used facial expressions. You can slightly exaggerate the portrayal of emotions with the frequently used manga features, such as an enlarged scowling mouth to express anger, or beads of sweat to indicate nervousness and embarrassment. These sweatdrops can also be used to imply bemusement towards other characters.

The Anatomy of Emotions

Emotions are critical for our understanding of other people in the real world, and so in comics they matter a great deal for conveying how a character feels about an event. In some cases they can belie the character's words, giving the reader the truth despite the deceptive dialogue. A character who shows no emotions at all feels wooden and unreal, while an inanimate object given a face and an expression can evoke a surprisingly intense feeling.

Faces are very mobile, and emotions are conveyed with more than the eyes. Imagine feeling angry, or happy, or upset. It's common to display misery with downturned mouths and possibly lowered brows, but in fact the whole of the face pitches in. Looking at the face, there are at least six very mobile areas, all of which contribute to displaying emotion:

The head itself. Is it angled up, or down, or tipped to one side? Raising your face while talking to someone can be considered snooty (unless they're a lot taller than you!), while looking down or to the side is often considered a sign of embarrassment, or an indication that you are lying. Tipping your head over can imply thinking.

The eyebrows – an often-forgotten but very important emotional indicator. Eyebrows are involved in every emotion we display; raised to indicate surprise or shock, lowered for anger, one tweaked upwards to indicate cynicism – they can change or intensify any emotion your character is showing. Never forget the eyebrows!

The gaze. Are the eyes rolled upwards, or staring down? Is the character averting his eyes? Shifty expressions are all about the eyes. In manga, because the eyes are so exaggerated, you have the additional emphasis of pupil size. The iris expands and contracts to permit additional light into the pupil in darkness or to protect it in light, but widened pupils also indicate interest and a greater level of excitement, while constricted pupils send a colder, less interested signal. Widened pupils in manga are typically used to indicate trust and, in an extreme example, 'starry-

Expressions are crucial for establishing characters.

Changing just one facial feature can result in very different expressions.

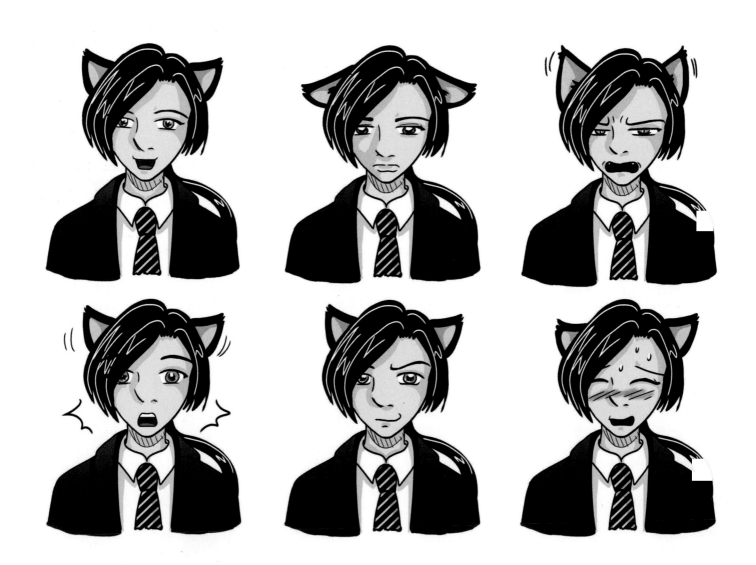

Examples of Corbyn's expressions.

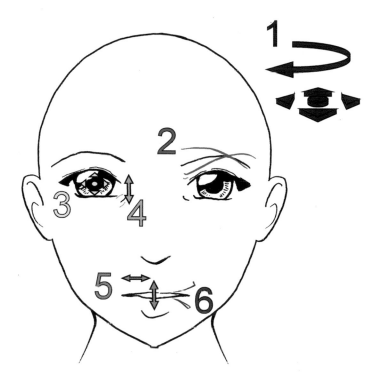

Face shape and the six areas of emotion.

eyed joy', although that could be considered a form of visual grammar (see below).

The eyes themselves – are they opened wide, constricted, or closed? Generally, wide eyes indicate either happiness or surprise, and a narrowed gaze can show distrust, consideration or dislike. You can emphasize the effect of the eye shape by adding small lines at the corners to mark the muscles contracting the face.

The mouth: open or closed, and how wide? A slightly open mouth is often a sign of relaxation, indicating the character is at ease, although a closed mouth doesn't mean the character is ill-at-ease. If a character is laughing, crying loudly or shouting, showing the mouth wide open will emphasize the emotion.

The mouth shape. Are the lips pursed, indicating disapproval or contempt? Curved up, which shows happiness, or curved down to indicate dissatisfaction or disgust? Twisted to one side, perhaps, when the character is grimacing in pain or surprise?

Basic Emotions

Interest in human emotions stretches back at least to ancient Greece. Some recent research has suggested that there are six basic emotions: fear, sadness, happiness, anger, surprise and disgust. These make convenient bases for the artist to work from. Draw your character with each expression and see what their face does. Concentrate on the areas described above. If

your character is happy, their mouth might be curved upwards, but what happens to their eyebrows and their eyes? Not all characters will use the same emotions, of course – an expressive character's happiness will look very different from that of a shy character.

To get more complicated emotions across, you can try extending or combining the six bases and see what emotions you end up with. Joy is an extension of happiness, terror an extension of fear, for example. The chart shows the six basic emotions and their extensions, with the mildest emotion at the left and the most intense at the right. From top to bottom, it shows sadness, happiness, shock, fear, anger and disgust. You can also see what happens when you combine some of them: The intermediate emotion between sadness and happiness is that bittersweet feeling associated with changes and endings; leaving school, for example, or leaving home. If you mix happiness and surprise, you get amazement; surprise and fear produce a startled face. Fear and anger combined can look like jealousy, while revulsion is a mix of disgust and anger. These are just a few examples of the possible combinations; you could also mix surprise and disgust to get a kind of shocked horror, for example, or sadness and fear to get dread. Experiment with your character's face, and see what happens to it when you move eyebrows, eyes and mouth to indicate the emotion he or she is feeling.

Not everything fits in quite so neatly, of course, but this is a useful place to start. With complex emotions, the kind you find hard to even describe, try thinking about how you would feel in that situation, and what would happen to your face.

There are multiple resources out there for looking at emotions and how they are displayed. The example given above is just one

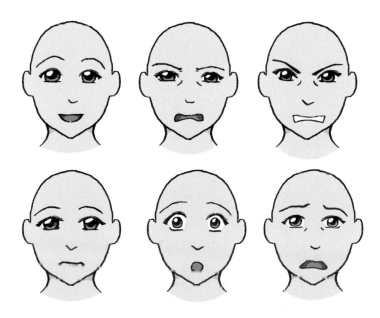

The six basic emotions: happiness, disgust, anger, sadness, surprise, fear.

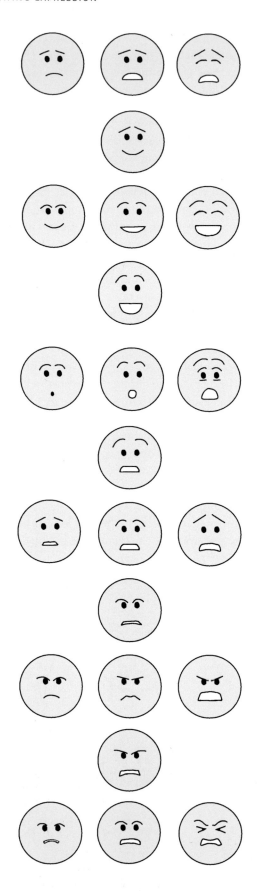

Extensions and combinations of the six basic emotions.

way, and you can learn a great deal from continuing your research into other ways to classifying and portraying emotion.

Visual Grammar

Within illustration and visual storytelling (manga and comics), there is more allowance to go over the top with expressions compared to other story-telling mediums. Make the most of this. Be imaginative! You can get away with almost anything when expressing emotions through drawing – even adding animal ears to your character. This sort of 'shorthand' is known as visual grammar.

Visual grammar is a great trick to use if you want to show an emotion but don't want a funny moment to become serious. It can also be good if you are showing characters from afar and need a simpler way to show an expression. It is often used to make a character more likeable (cuter) but of course, sometimes it's just fun to use!

Speech expressions can also be turned into a very literal visual expression. For example: if you wanted to draw a shocked character, you could turn the phrase 'you scared the life out of me!' into a literal image of a character turning white, and their life leaving them at the shocking moment.

You can visually express the physical feelings gained through certain emotions, for instance vertical lines down a character's face to give the impression of a chill going through them as they are scared or nervous. You could add the likeness of an animal to a character to express an emotion; dog ears when a character is being overly loyal, or fox ears if a character is being cheeky and cunning.

Sometimes you may want to show a serious emotion without ruining a funny moment. Visual grammar is great for this. As an example, to express sadness without being realistic, draw waterfall-like tears running down the character's face.

Try coming up with your own visual grammar too. Think of an emotion and exaggerate the key points of that feeling.

Gestures

Like facial expressions, gestures are an important way of conveying a person's emotions. Our hands are rarely idle – we make small tugging, pulling and fiddling movements even when we seem otherwise still. Gestures can express a wide range of feelings, from excitement to uncertainty. Younger or child-like characters usually gesticulate a lot, whereas older, serious characters are more reserved. A typical manga gesture is the 'hand behind the head', which is often used to indicate embarrassment. Think

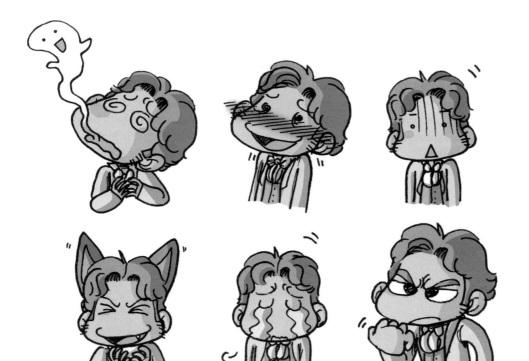

LEFT: **Examples of Henry's expressions showing different kinds of visual grammar.**

BELOW; **Examples of Corbyn's gestures.**

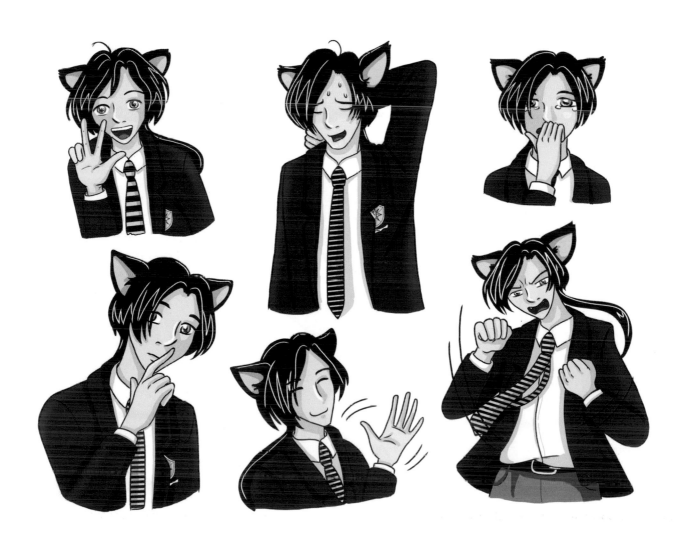

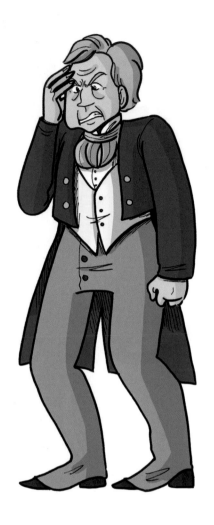

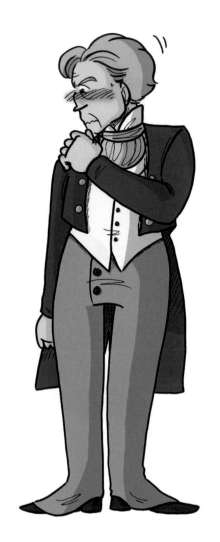

ABOVE: **Henry, exasperated.**

TOP RIGHT: **Henry, annoyed.**

RIGHT: **Henry, contented.**

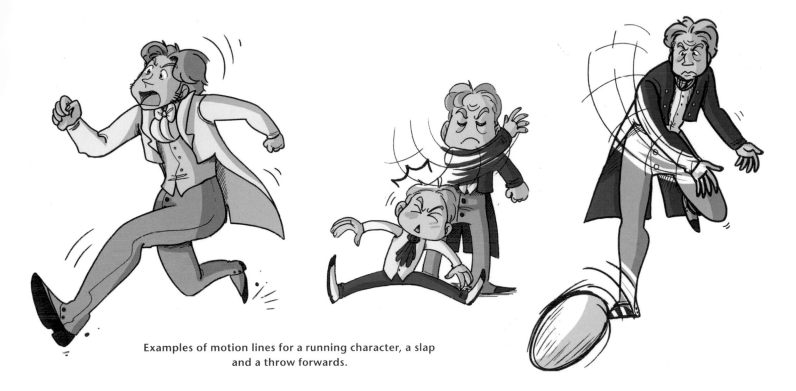

Examples of motion lines for a running character, a slap
and a throw forwards.

able to make eye contact, could keep their legs closed and hands in pockets. They are more likely to be anxious around people, and keep their shoulders raised in guard.

A whimsical personality would result in whimsical actions. A character of this nature isn't likely to stand still at all, but continually look around and keep moving. A proud character, on the other hand, may constantly think about how they appear to other people, so their hands would be controlled at their side, and the legs and feet kept straight and in check.

Expressive Poses and Motion

Strong emotions are expressed not just through the face and body, but through how a person moves. A content person would stand or lean back in a careless, relaxed way. A scared person would lower their head as if crouching down, and take small, tentative steps. Extreme joy culminates in an excited high jump, whereas sadness can be seen in low postures; a drooping head and hunched shoulders, not just in a sad unsmiling face. Because extreme emotions result in sharp, sudden and quick movements, consider the effect they have on hair and clothes. For example, a sudden angry swipe or a joyful leap would result in the character's hair flying back and loose clothing flowing around them.

Adding motion lines emphasizes movement and therefore adds expression to a key moment or action. Think about where

ACT YOUR CHARACTER'S EMOTIONS

One common mistake in manga and comics is to try and convey emotions entirely through dialogue and/or facial expressions. Words of course are very important for getting feeling across, but have you ever been so angry you couldn't speak for fury? So upset that words simply couldn't describe it? Or have you felt something very strongly but been unable to mention it at the time? Sometimes words don't fit an emotion or a context. It's also important to remember that the face is not always enough on its own. Think about your angry character; is it really likely she will be standing straight up with her hands relaxed by her sides?

If you are finding it difficult to picture how your character would show their emotions through their body and face, get up and act it out. Imagine yourself in your character's place; how would you react? How would you stand, sit, move? How would you vent your rage/display your exultation? What shapes does your face make when you feel what your character is feeling? If you find yourself pulling faces while drawing, you know you're on the right track!

the action is most present in the body and add motion lines next to it to exaggerate movement. Let the body slightly imitate the motion lines you have made, it will make an image feel more dynamic, as though the image was captured mid-movement. But remember body limitations as well. Think about the length of limbs and proportions in body anatomy. Observe how limited your own body is to help figure out difficult poses – although sometimes your characters may have different physical limitations.

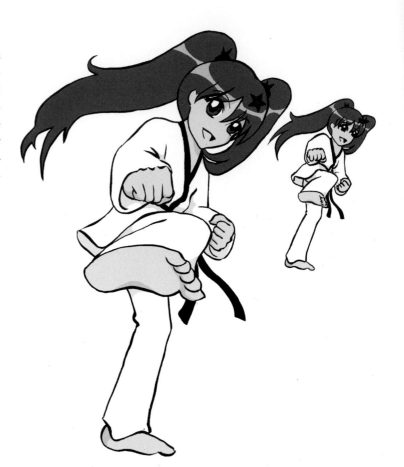

The magnitude of foreshortening depends on how close the character is to the reader.

Foreshortening is the effect of part of a character's body being much closer to the viewer than the rest, and thus appearing disproportionately large. A punch is a common example.

Foreshortening

One of the inevitable results of having an interesting, expressive character is that, at some point, you will have to draw them in an awkward pose and that will probably involve foreshortening. Foreshortening is the effect created by one part of the body being closer to the viewer than the rest. Imagine looking at someone who is punching you in the face; just before the fist lands, what do you see? Assuming you haven't been sensible and tried to dodge the hit, you will see a big fist taking up most of your vision. But the aggressor is still standing next to you; he has not become as big as his fist now appears. Because the fist is so much closer to you, it appears that much bigger, and this effect is important to master in order to attain properly emotive poses. You may be able to get away with keeping all your characters at the same distance from the viewer for a few pages, but if you do an entire comic like that it will feel flat and dull.

The first thing about foreshortening – and indeed any awkward pose – is not to be afraid of it. If your story calls for a panel showing your character parachuting feet first at the reader, then plan it in. Don't restrict your story by what you know how to draw, but be willing to challenge yourself and explore possibilities.

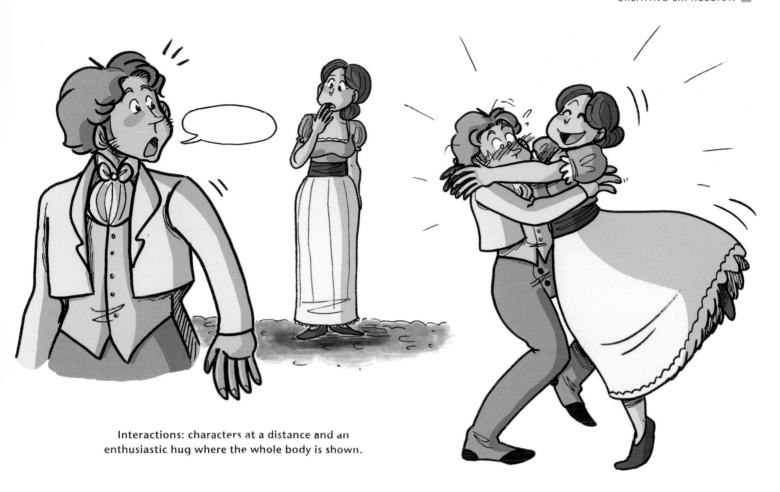

Interactions: characters at a distance and an
enthusiastic hug where the whole body is shown.

The next thing is to use a reference. If you don't have a handy friend to pose for you, try taking photos of yourself, or even pulling a pose and looking in a mirror, and trying to remember enough of what you see to reproduce it on the paper. When using a reference, draw what you see and try not to let what you 'know' about the body influence you. For a character throwing a punch at you, if the fist appears three times as wide as your head when you look in the mirror, then draw that on the paper – even though you know that in real life the fist is smaller than the head. If you're finding it hard to draw on paper what you see in the reference, try to look at where the figure isn't, and draw that – it will be an abstract shape and easier for you to reproduce accurately. Then you can draw in the details of the figure itself.

Finally, remember that the magnitude of the foreshortening – how large a hand appears, for example, when held in front of the character – is dependent on how far away the character is. If a person is close to you holding their arm stretched out in front of them, that hand will appear much bigger than their other hand by their side. If a person is a long way away from you, both hands will appear much the same size, because the distance from person to hand is tiny in comparison to the distance from person to viewer.

Character Interactions

When drawing scenes in a manga where characters are talking to each other, make sure you don't just stick to shots of each

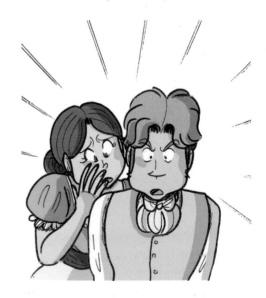

Interaction: whispering – and a shock for him. Here a slight
angle is used to give impact.

individual as they talk. Draw wider views of your characters together as they interact. Mixing these with close ups and individual shots can make a page more visually interesting for a reader, as well as expressing the relationships between characters. There are many different ways characters can greet, talk and say goodbye to each other. For example, if two people embrace each other in an awkward hug, they are not just saying hello; it also shows the dynamics of their relationship. Just as emotions displayed on the face can tell the reader far more than what the character is saying, so the way a character moves to do an action tells the reader far more than what the character does.

Distance and position can be just as important as expression when characters are interacting. Showing a set distance between two characters can make both look more striking and help symbolize a relationship, emotion, or narrative between two people.

Angle can be very important too. When a more dynamic angle is used, that is looking down or up at characters, it can show that something is wrong, or create an atmosphere for a moment. If one character is displayed at the top of one panel, and in the next panel another character is placed at the bottom, this can indicate a hierarchy – that's a particularly useful technique if the submissive character is taller than the dominant one!

Using any of these techniques can be especially good if you want to explain or express a moment in a story without having to say it within dialogue, or force it through the narrative.

Remember to think about perspective and height differences when doing images of people interacting. Keep a note of how short or tall your characters are in comparison to each other. Being inconsistent with height differences can ruin the narrative flow of your comic, and a record of this can also help you with perspective.

To help measure height and distance between characters, use a 'horizon line', a straight line across the panel. This is effectively the reader's eye line and is often the actual horizon, and frequently it will also be the eye line of at least one character in the panel. Remember that if your characters are the same height standing next to each other, their eyes will be at the same level no matter how far back one is standing from the other; if the eye line of the character in the foreground is on the horizon line, so is the eye line of the character in the background.

You can also use a horizon line to help when you're drawing characters who are a different height at a distance from each other (if they are a different height, of course, at least one of them will have an eye line above or below the horizon line). Measure how many heads (or half heads) there are for each character from their head to the horizon line if the character is standing in the foreground. However far away they are, as long as the ground is flat, they will always stick to that same proportion and position. In the example, Marre is standing in the foreground and her apprentice is some way away. If he was in the foreground, as the blue-lined image shows, his head would be half a head below the horizon line (which is Marre's eye line). Thus, in the background, his head is still half a head below the horizon line. Note that the eye line of Marre's blue-lined image next to him in the background is still at the horizon line.

This method works even if you are looking down at the page at an angle, as long as it's not too steep. Keeping this in mind, you can easily make sure perspective is accurate and characters are the right size in comparison with their location in the surroundings.

However, remember if the ground is sloping, your character's height differences will change. If a foreground character is at the bottom of sloping ground, their eye line will be lower, and they will appear to be shorter than the background character, even if they are normally taller, and vice versa.

Complicated Scenes

As characters in manga don't exist on their own, drawing complicated scenes with a lot of participants is inevitable. It may seem like a daunting task at first, but can easily be conquered with a bit of planning!

First of all, consider how many people it is realistic to fit into a picture, which ones will take centre stage, and which ones can be moved into the background. Placing the characters in such a way that their eyes are all approximately on one level helps make the scene easy to understand. Roughly sketch the characters – the ones in the background first. Make sure their poses are right and important details such as faces do not overlap or get

TIPS FOR PERSPECTIVE AND ANGLES

Perspective and angles are tricky, but getting them right and using them well can make a huge difference to your pages. Find some books on perspective, and simplify your characters and backgrounds before drawing them out properly. Remember as well though, that nothing can be perfect. Keeping all those measurements and perfect lines in final images can result in stiff artwork that lacks movement or life. Try to create a balance between perspective that is accurate enough, but doesn't overwhelm your final drawings.

Use a horizon line and head measurements to estimate the relative heights of characters at a distance from each other.

obstructed by other characters. After your sketch is done, flesh the characters out and add details.

In the example below you can see a sketch with dummy figures, where each of the characters' positions are identified. No significant details are added at this stage, aside from the sketchy facial expressions. Despite the lack of details, you can see which characters are in the centre of action; the couple cuddling, and other characters' reactions to them. The dotted line indicates the approximate eye level.

On the fleshed-out picture, the characters' positions remain unchanged. We can see their emotions relating to the girl and boy in the centre. The girls on the forefront are gossiping; one of them looks embarrassed. The boy on the right seems to be cheering the couple on, whereas Corbyn is possibly taking a photo. The girl in the background is looking at the couple across her shoulder – is she disappointed in the boy's choice of girlfriend? Does she wish she could take her place? Is she looking hopeful?

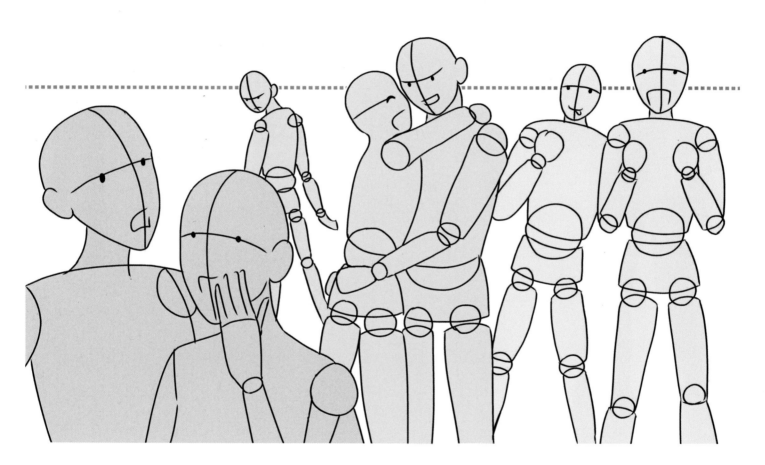

Framework for a complicated, multi-character scene.

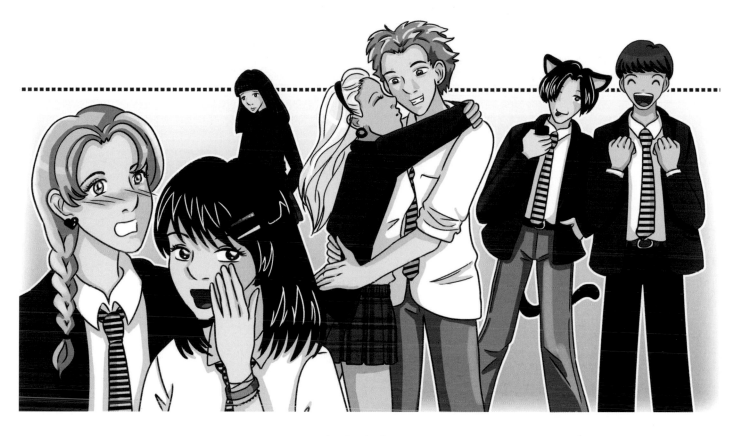

The finished scene.

CHARACTER ROLES

Identifying a character type and giving your character the appearance and behaviour to match that type is an important part of character development. Most manga characters can be put into certain pigeon holes, with corresponding roles, expectations, and implications. As characters interact, they counterweigh and complement each other. A shy and reserved main character is often paired up with a loud, brassy best friend or girlfriend as a sidekick. A group/band of characters is likely to include a variety of types; immature, quiet/mysterious, comical, eccentric and so on. Of course, one character can combine several character types in him/herself. For example, many manga villains appear eccentric, mysterious, and at times, comical. These pigeon holes or 'boxes' are simply helpful starting points – a properly developed character will be far more than just a hero or a sidekick.

Character Types can be Mixed and Matched

The purpose of this chapter is to provide tips and pointers – it is not a rule book to be followed to the letter! Think of the character type as a 'base' or skeleton for your character. You can combine features of different types in the same character, so play and experiment to achieve results that are surprising and unexpected!

Here are examples of some (but definitely not all) character types you commonly see in manga and anime. Think of any popular characters you know – can you identify their character type?

Hero
Villain
Henchman
Sidekick
Mentor
Straight-laced
Strategist
Emotional

Anti-hero
Wiseman/woman
Child-like
Comic character
Mysterious character
Professional (e.g. engineer, teacher, musician)

Below, we have taken some of our characters and shown what different types they can fall into, and how you can achieve the desired effect by altering the character's appearance, expressions and poses.

Character Introductions

Ivy

Ivy is a typical sixteen-year-old schoolgirl, except for her unusual ability to predict the future in her dreams. She shares her dreamscapes with a 'dream friend' named Marcus, and together they try to work out how to avoid future disasters. Of course, she also has a 'waking' life, which requires just as much concentration and effort as her dream world. Whimsical and imaginative, she could easily be the hero/main character in a fantasy/comedy/action story, but with a different twist she could be a very effective high school villain. As a side character, she could be mysterious, eccentric, emotional, comic, or even child-like – or, of course, a combination.

Corbyn

Corbyn is a catboy; a male equivalent of catgirl, an anthropomorphic creature common in manga. Because of this, Corbyn possesses certain cat-like traits, such as agility and sensitivity to people's scents and feelings. Although Corbyn was created with

NARRATIVE ROLES

It's important to remember that the types described here are distinct from narrative roles; the protagonist of a story does not have to be a 'hero' type character. Narrative roles are simply ways of classifying characters; they don't indicate anything about the character himself or herself. A protagonist is not always 'good' – indeed, some very successful stories have been told using a villain as the protagonist! However, it is useful to know what the narrative roles are, and to think how they might apply to your characters and story.

The main narrative roles include protagonist, antagonist, focal character, viewpoint character and side or supporting characters. The protagonist is the main character, and normally the character who tends to take central stage and with whom the reader identifies the most. Sometimes the role of protagonist is split, with one character taking central stage and being the driving force in the story (the focal character) but another character being the actual protagonist, the one with whom the reader identifies and empathizes, and whose story the reader is actually following.

If your protagonist is a mysterious kind of character, you may wish to use a viewpoint character, through whose eyes the reader sees the main character. The viewpoint character does not need to be someone in whom the reader is particularly interested; he or she is not a protagonist, just a helpful way of looking at the protagonist.

The antagonist, on the other hand, is the opposing force in the story, the creator or driver of the conflict. Antagonists do not have to be evil, just opposed to the protagonist. They don't even have to be people; a raging storm would make a good antagonist in a story about survival.

Side characters are there to be part of the story, to bring out the protagonist's (or antagonist's) role. They may be necessary parts of the setting, or important to the story in their own right.

Remember, whatever roles characters take in the narrative, they all deserve time and effort to develop their personality and bring life to their own little story, which is an important component of the overall story.

LEFT: **Ivy, the dreamer.**
BELOW: **Corbyn, the catboy.**

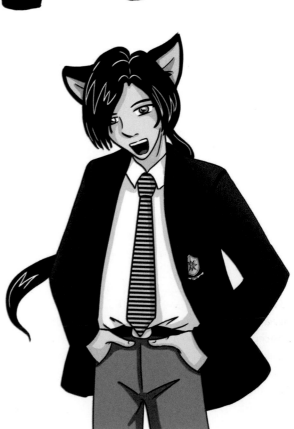

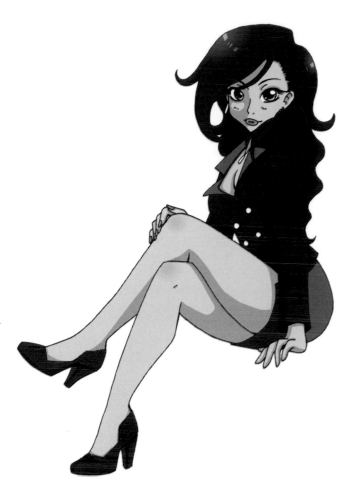

Carmel, the entrepreneur.

Henry

Henry is a character that changes personality over time, and his character role changes as he gets older. As an older man he is bitter, unsociable and focused on the past, pushing his problems onto main characters. He would be an obvious choice for a villain! If he was put in a different story setting however, in spite of his grumpy nature, Henry's age and experience could also easily make him a mentor, mysterious character or professional.

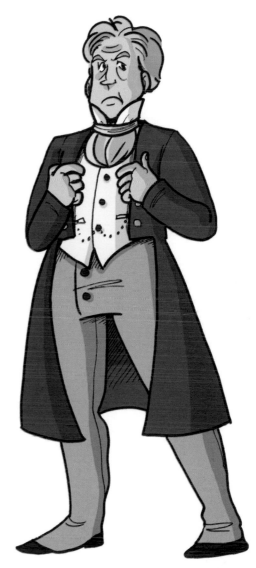

Henry, the aristocrat.

the view of becoming a main character in a high school drama/comedy manga, he would make a great supporting character if he was paired up with a reserved, level-headed protagonist. Thus, his abilities would be applied in an unexpected context! Corbyn could be a hero, a comical character, even a child-like and sometimes eccentric character type – depending on what he's up to!

Carmel

Carmel is the head of an exclusive cosmetics company. She began her business by selling handmade facial creams to friends. Thanks to her confidence and charm, her humble business grew to become the large company it is today. Carmel's position gives her a lot of power over the people within her company and the customers of her products. This wide range of influence would be the perfect platform for a villain to begin a global empire. Carmel's entrepreneurial experience could also make her a good mentor figure. With her brassy personality she could also work as a comic character if she had some other, more sensible, characters to interact with.

Marre

Marre is a middle-aged engineer, from a technological but not futuristic setting. When she was young she joined the army, which is where she trained in mechanics. But when the civil war started she defected and joined the rebellion. Many years later, now peace has come, she works as a civilian engineer. She could

Marre, the engineer.

easily be a mentor character, given her background and experience, but that history could also make her a villain, a mysterious figure or a hero. She could not play a child character, obviously, nor is she particularly suited to be a comical or emotional type of character.

The Hero

In every story, there is at least one hero – a character embarking on a journey of any kind; physical, spiritual or emotional, and emerging from it a changed or improved person. The traditional view of a hero is a physically or mentally strong, brave and confident character. However, this is not always true. There is always the temptation to make the hero of the story too perfect and give them an impossible combination of beauty, wisdom, bravery and luck. However, it is important to remember that heroes, just like any other character type, possess flaws. It could be a bad temper, habitual lateness, or an inability to do magic or play football. A realistic, complex, multi-dimensional hero adds richness and depth to the story, and makes it easier for the

TAKING INSPIRATION FROM REAL LIFE

Sometimes the most complex characters and stories are inspired by people you know in real life. To help develop your characters, observe the people you know, maybe even yourself, and think about what character role they fit into. Look at their personalities and observe what traits they have, how they react to people, and what kind of situations they get themselves into. Building in personalities or observations of real people you know can create richer characters, and give you a better understanding of how to develop basic starting-point characters into more complex personalities. Observing from life can also help give you ideas for the situations your characters will face.

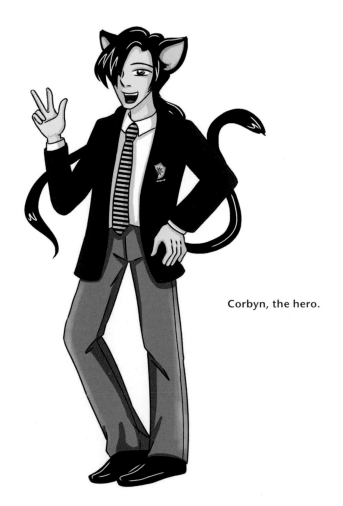

Corbyn, the hero.

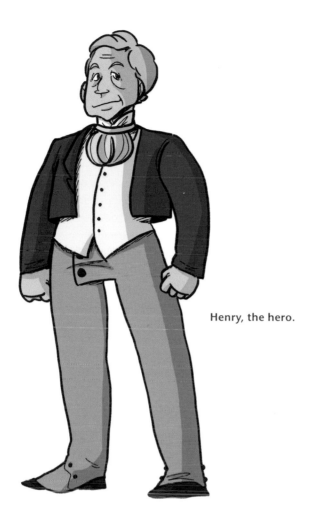

Henry, the hero.

LOOK LIKE A HERO

Create your hero's look bearing in mind the points above. By all means, make them look 'heroic' if their personality allows it. A straight back and head held high are indicators of confidence. Two common gestures for a hero would be a thumbs-up or a V-sign. At the same time, ensure that you do not overdo your character's heroic look to the point of caricature. Make them look confident but not self-centred.

The Villain

It is tempting, when creating a villain, to make them as evil and horrible as possible; to give them fantastic super-powers, a billowing cloak and a penchant for dishing out cruelty to small, cute animals and/or children. While this sort of villain can be entertaining and suitable in certain contexts, often the less obvious villains are the more interesting ones. A villain could be a girl at school whom everyone loves, but who is secretly making someone's life hell. It could be a king turning a blind eye to the welfare of his subjects so that he can live a richer life. Or even a quiet employee who is gradually pushing higher paid colleagues out of the company with blackmail and manipulation in order to take their roles. These roles are far from the super-powerful bad guys who sit cackling in their secret lairs, but are no less villainous.

reader to relate to them. Remember that your main character does not have to be a hero-type character.

Heroes are often expected to be big, bold characters, extending their influence and authority over everyone else, but this isn't always the case. In many stories, heroes are ordinary people, and the potential, special powers and strengths they possess aren't always obvious. A common storyline in many manga and anime is an ordinary, weak, lazy girl character suddenly finding herself on some sort of a mission. Her short-comings don't make her any less of a heroine. Likewise, heroes aren't always non-violent and saint-like. But, unlike villains, heroes' motives are always 'to put things to rights', even if their actions are far from noble. For example, a criminal who commits murders to avenge his family can be a hero, too.

Character development for heroes is just as important as it is for other character types, if not more so, as they almost always take centre stage. Think carefully about the storyline and your hero's role in it. What prompts your hero to embark on the journey they are taking? What are their motives and what are they trying to find or achieve?

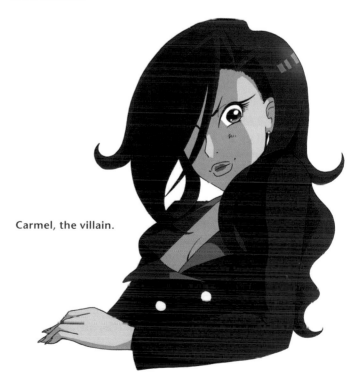

Carmel, the villain.

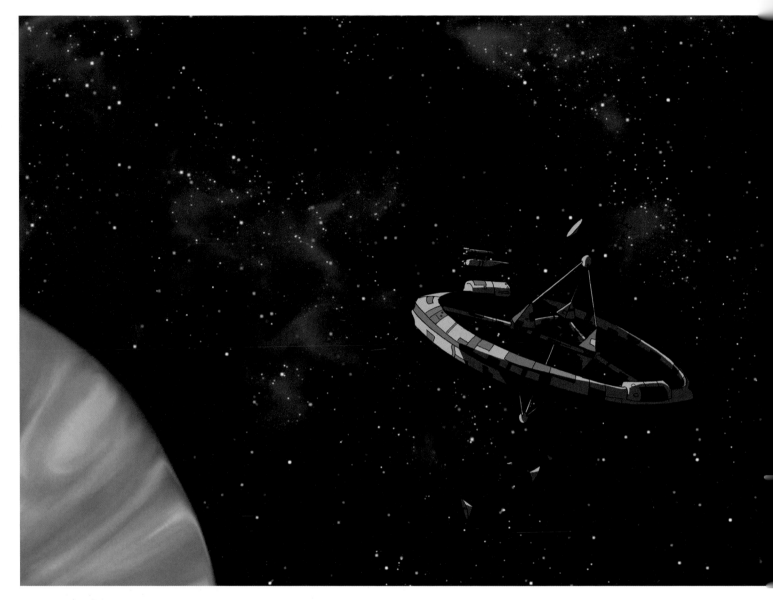

ABOVE: **A space station; earth may be distant, long-forgotten.**

OPPOSITE: **A fantasy scene; explore situations that wouldn't be possible in the real world.**

igator is a job, and the story generally follows the case), and thrillers are commonly set in the modern day. It may be helpful to consider the story you are working on and the type of characters you are designing. A suave detective in the mould of Sherlock Holmes may not work so well in a prehistoric setting – although again, if it can be made to work, then it could be excellent! No matter what setting you use, the most important thing is for it to remain absolutely consistent and believable throughout your story.

Example Settings

Science Fiction

Science fiction is a hugely wide setting, encompassing anything from aliens invading present-day Earth, to five years in the future when, for example, computers could have become small enough to implant into the human cortex, to an unimaginably distant time when the galaxy is colonized, not just by humans but by a plethora of alien races. Earth may be distant, long-forgotten, never even mentioned. Technology is usually advanced from the present day, and this will need careful thought because it will impact on your story. Perhaps one of your characters is in a different star system from another. How long will it take for a message to pass between them? Or does your world have instantaneous information transmission? How do they travel?

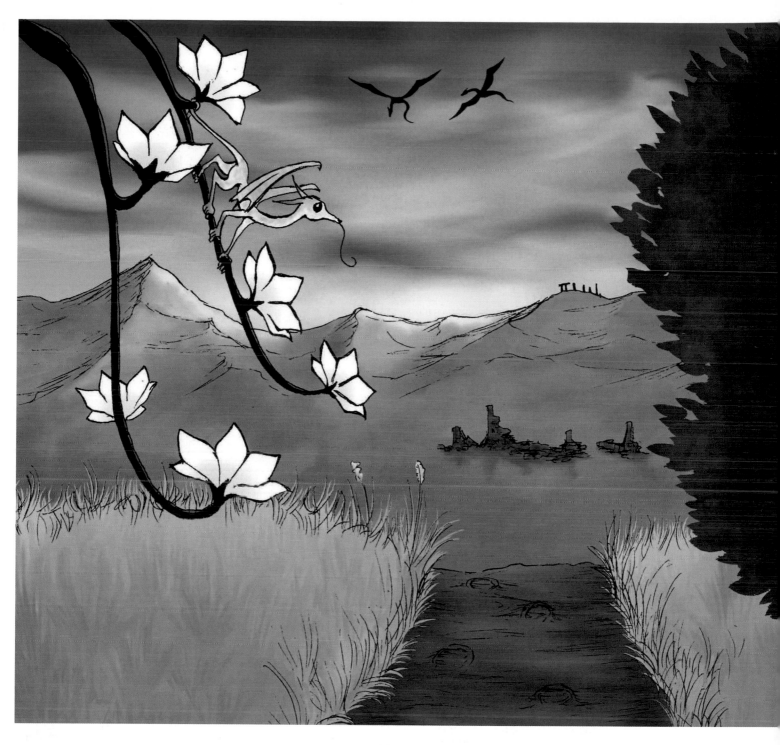

Obviously it's not necessary to provide scientific justification for everything (if it was, every science-fiction story utilizing faster-than-light travel would be in trouble!), but you do have to keep your technological advances believable and consistent. Also consider the impact of that technology on society, and bear in mind that your characters are likely to treat these amazing technologies as normal, run-of-the-mill everyday things. It's no big deal to project your holographic image across a galaxy, after all. Everyone does that nowadays.

Fantasy

If science fiction is a wide setting, fantasy has the potential to be even wider, as it encompasses the modern-day real world and anything the imagination can create either side. It lets you explore situations and events which wouldn't be possible (or plausible) in a real world setting. Because everything is possible, it is absolutely crucial to be consistent – using fantasy is not an excuse to avoid research and planning. Fantasy often involves

A manor house, a potential setting for an historical story.

magic; if you have a magician, there must be a reason why he can't just mutter a spell and put everything right before the story has even started. Cleverly limited magic can be very powerful in a story.

Wherever your fantasy is set, it is useful to consider the real world equivalent. Are there knights, kings and dragons? Think about the mediaeval period in Europe. Are there fierce fighting clans among wild mountains? Think about the ancient Celts. If you can find a period of time and a place that somewhat resembles your setting, it will be very useful in helping you to keep your story believable and consistent. Of course, don't feel you have to stick to human characters only; fantasy stories are known for featuring multiple races such as elves, dwarves and goblins. Why not make up your own? But even an elven knight needs a blacksmith now and then, so what were blacksmiths like in the twelfth century?

Historical

In some ways a real world setting such as the Victorian era can be much easier to work with than a largely made-up setting. If you do your research well, you will need to do very little large-scale world-building, although every story requires world-building on a small scale. How quickly could a message from London reach Paris? How would your characters travel across Britain? Look it up. There's no need to try and work out just how fast a winged horse could fly, for example.

However, this sort of setting can also be much harder because the details are a matter of public record, and if you get one wrong it is likely that somebody with expertise in that area will spot it. For any real-world setting, particularly one where you do not have personal experience, careful research is crucial. The internet has made this a lot easier, but don't let that be an excuse for laziness.

Modern

If there is a setting that offers truly limitless possibilities, it is the modern day setting. It is likely to be the environment that you are most familiar with. You can choose any theme within this setting, from a crime-fighting police drama to a surreal horror story or a school-based comedy. In a way, it may seem that you don't have to do as much research if your story is set in modern times. In reality, it involves as much research, but it is usually easier to conduct.

You can actually visit places you base your story in, and see first-hand what they are like, instead of relying on someone

It may seem ordinary, but a modern day setting can offer limitless possibilities.

else's account of it, as you would with, for example, a Victorian-era setting. This does depend on your story, of course – if you are choosing to make a comic about a modern day astronaut, you will still have to do a lot of book research! Another advantage of a story set in modern times is that you don't have to stick to the existing rules of the modern world we live in, but bend them just very slightly to add a point of interest to the story. For example, an ordinary modern-day city setting where humans and elves live side by side – why not?

A Japanese temple; it might be tempting to set your story in the home of manga.

Eastern

As manga originated in Japan, it can be tempting to base your story in an Oriental setting – just like your favourite *mangaka* do! Haven't you seen enough *katana*-wielding Japanese warriors, stealthy ninjas and *Pocky*-eating schoolgirls in sailor uniforms to pull it off yourself?

In reality, the more familiar your story setting is to you, the more plausible it will look to your reader. If your story is set in a different (real, not made-up) country that you haven't lived in, or don't know too well, it is very hard to recreate its customs, rules and society and make the story look authentic. For example, if you are determined to have your story set in Japan, try to

move away from the impression of the country you would get from manga, and focus on its real aspects. Of course, most of the difficulty can be overcome with careful research – books and magazines, the Internet, or (if you're lucky enough) a trip to the country of your interest. Real-life accounts of people living in the country of your choice are very helpful.

School

Extremely common in manga, the school setting is easily adaptable for any genre. School-based stories are generally popular among high school students as they can easily relate to the environment the characters are in. However, you are not limited by typical comedy/romance scenarios – high school murder mysteries or vampire horror stories are also perfectly plausible. Nor

Schools can be any time and any setting you choose.

MASH-UPS AND ALTERNATIVE HISTORIES

The settings described here are just a few of the options available. You may have come across Steampunk, for example, a kind of extension of the engineering of the Victorian era which assumes modern or quasi-modern technology based on clockwork and steam. It is a combination of historical and fantasy settings with a dash of steam-powered science fiction, and it is a prime example of what can be called a 'mash-up', and depending on the details could also be an example of an alternative history.

A mash-up is what is sounds like; a squashed-together combination, a fusion of disparate elements. The term can be applied to anything, but in terms of setting, how about an historical drama with added zombies? If you think an element

commonly found in one setting would work well in another setting, why not try it? It might not work, but it would be interesting to find out!

Alternative histories, or alternative Earths, are settings very similar to this world but with just a few changes. For example, what would life be like today if the Roman Empire had never fallen? Or if magic really existed but was kept hidden by obscure sects or obsessive Government agents? The real world can be a hotbed of fantastical ideas just one small concept away.

These names, of course, are just labels applied in an attempt to classify bits of a story, and they really describe the endpoints of a spectrum rather than distinct subclasses. Don't be bound by them, but use them as a springboard to inspire your own world.

Research is crucial.

talking to people who lived through the period you're writing about can really lend atmosphere to your story and make it believable. Other people can even give fresh takes on modern day stories, for example if you have a story set in an all-boys or all-girls school and you never attended one, but know someone who did!

Go there: again, this option is limited, but not as much as you might think. If you're creating an Arthurian story, visit Tintagel or North Wales, depending on which version you prefer. If your story is set in Bath in the Roman times, it would still be very useful to visit the modern day city. Or if you are simply travelling and see a building that may be useful, take a picture. You never know when it will come in handy.

Museums: find a museum dedicated to your setting and area of research. You will be drawing your story, after all; pictures of a forge may well be more useful than a detailed description of what the blacksmith does, although both would be better still.

does the school story have to be set in modern times. What was an Ancient Roman school like? Isn't a Victorian boarding school with a mysterious headmaster a perfect setting for a story? Or maybe you can imagine the school of the future? Regardless of the precise time period, the characters of a school-based story would still have a lot in common with modern-day students – friendship issues, conflicts with teachers and competition with peers. While researching your school story, it is helpful to think of the exact school type you are basing the story in. If possible, visiting a school can prove to be very beneficial. Many schools hold Open Days where you can get plenty of inspiration. Picking up a school prospectus would give you an idea of the school's rules about things like school subjects, uniform, rewards and sanctions. If you are still at school yourself, you are in luck as you have a ready-made model of your setting! This may help you see your own 'old, boring' school in a new light.

Rule Number Two: Write it Down

This is true for every aspect of storytelling. Write down your research and ideas. Write them in a notebook, type them on a PDA, take photos and make notes, whatever works – but don't let them escape. You never know which details might come in useful. If you're using a library, you may be able to photocopy the relevant sections of a book – just ask the librarians about it.

Rule Number One: Research

Where can you find out about your chosen setting? The internet is an excellent first port of call, but don't let it be your last. Here are some ideas of places to look for more information.

Libraries: a good book on the culture you're researching can be much more informative than a set of web-pages. Having the book on hand can also help when you want to quickly write things down or compare images – 'Alt – Tab' isn't always your best friend on the computer and can be annoying to work with.

Other people: obviously this option is limited to recent history and modern day (unless you can find a lecturer on the ancient Egyptians willing to discuss your story about Tutankhamen), but

Write it down!

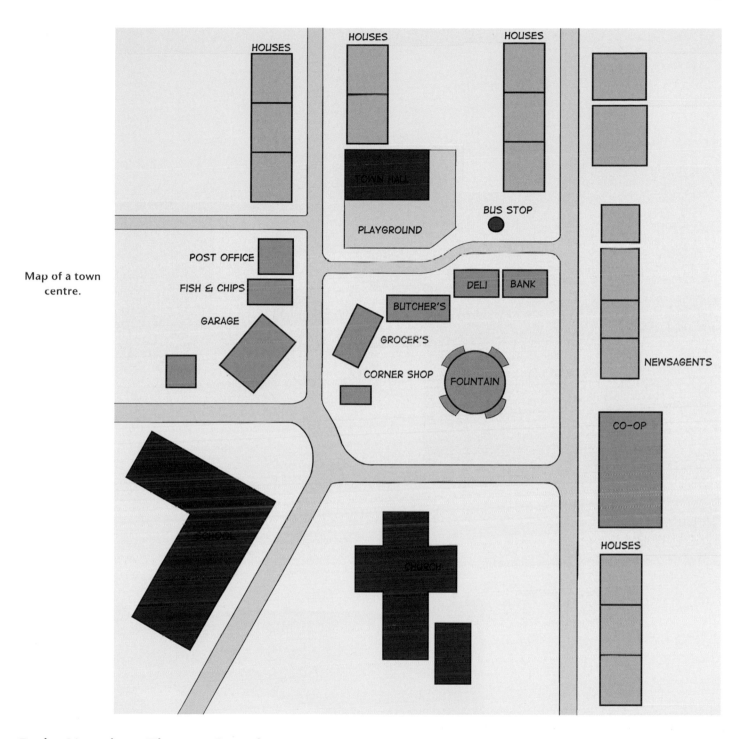

Map of a town centre.

Rule Number Three: Consistency

Your invented world needs to be consistent – if it's not, readers will notice. If your characters start off needing three days to travel from city A to city B, that distance needs to be kept to and not covered in one day later in the story, or it will stick out like a sore thumb. This is why it can be easier to work with the real world; the consistency is built in and we know instinctively how it works. Historical fiction also makes it easier for you; most things are a matter of record (depending on how well-docu-

mented your chosen period is). But far future and fantasy worlds have to be laid out in detail and with checking to make sure they are thoroughly internally consistent.

Making Simple Maps

A good place to start is a map; if you know how far apart buildings or cities are, you won't have to remember it takes three days to get to city B; you can just look at your map and see how far

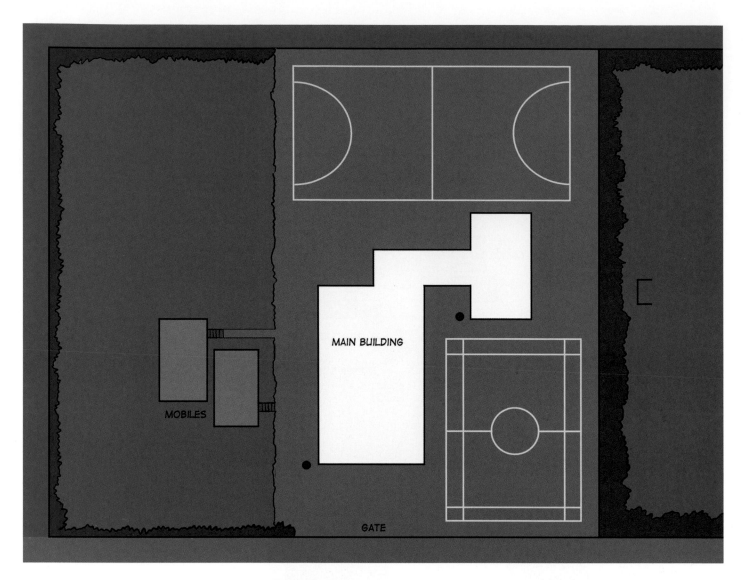

MOBILES

MAIN BUILDING

GATE

ABOVE: **Map of a school.**

RIGHT: **The school.**

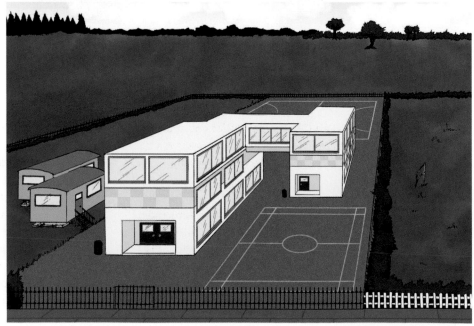

To Central
Crossing

Lifts

Eastern Hub
Shopping
Arcade

Eastern Hub: Main Level

Map of a section of a space station.

it is. More importantly, when the time comes for your travellers to move on from city B to city C, you'll be able to place it accurately on the map – and know immediately how long it will take them to return to city A.

It's not just countries that need maps, though – you can draw maps for cities, plans for buildings and even layouts for a room. For any setting, even one as small as a single room, knowing where parts of it are in relation to others allows you to draw it accurately and to place characters correctly. Also, of course, if you as the writer don't know where your characters are in relation to their setting, it's a fair bet the reader won't either!

World Mechanics

Consistency includes more than maps, however. Your world must be believable, and that means it must have its own internal logic. The most obvious issue here comes from the use of 'strange forces' – commonly magic, but any advanced technology will cause the same problems. Your readers must believe that what your characters can do is consistent with the way the world works. If a magician is great at illusions, surely you'd expect them to be using an illusion constantly (unless they're naturally good-looking!). If they are not constantly creating illusions, why aren't they? What does faster-than-light travel

INVENTING THE CHARACTER

There are two common ways to come up with stories and characters. One is to create a character or group of characters, and then the story in which they can star. The other way is to create the story before designing the characters to be part of it. Both ways work well, but both have their pitfalls and problems.

If you invent your character first, you run the risk of 'spoiling' them; of making a setting and plot purely to show off your wonderful character, and his or her back-story and capabilities. The character can be glorified at the expense of the story and the other characters. The result of this is that you may end up with a thin, unsatisfying story and boring characters – even the wonderful main character will end up being dull and unsatisfying!

To avoid this, you should try to spend as much time on the story and the other characters as you do on your main character. Make sure he or she isn't too perfect; everybody has faults and flaws. A perfect character will actually come across as annoying, wishy-washy, or simply dull.

If, on the other hand, you have a story you want to tell and you need to design characters to be part of it, you run the risk of them being under-developed and unbelievable as people.

Spending too much time on your favourite character can result in a thin, unfulfilling story that bends over backwards to glorify your character.

However, designing characters to fit a plot could result in two-dimensional, unrealistic characters.

They must all have their own desires and motives; they are not there simply to drive the plot. After all, from their point of view, there is no plot! Each character deserves a little of your time and attention separate from their role in the story, just so you can get to know them. If you need a character that is shy and brainy, think about what other personality traits (and physical ones, such as dress choice or speech mannerisms) might fit them. If you also need somebody to be bold, reckless and impulsive, you'll need to add another character entirely; your cautious genius won't be a good fit for those personality traits.

Regardless of which method you choose, there are some things you should think about for every scene in your story. Ask yourself if the events make sense in respect to the setting, the rules of the world, the characters present at the time and what has happened so far in the story.

Sketching your character at every opportunity is a good habit to develop. You can even devote a whole sketchbook to a particular character and practise their facial expressions and poses. Make them try on different clothes and hairstyles, and draft out key scenes in your story. A short time spent sketching every day, on a train, while waiting for a bus, or during a lunch break, would soon add up and help you get to know your character. It is particularly important to know how your character conveys and expresses his or her emotions.

Spend time with your characters. Think about each one. What makes him or her unique; are they bold, impulsive, shy, or cautious? How would they react and interact in different situations? If you put them all in a room with a bowl of peanuts between them, who would reach out first? How would the others react to that?

Take personality tests on their behalf, and get to know them. If you like internet memes, you can complete them from the point of view of your character. This will give you an insight into their emotions as well as their background. Remember too that characters will grow and change during the story – indeed, a story where the characters don't change will feel lifeless and unreal.

Personality Types

There are multiple different ways to classify personality, none of which will capture the full extent of what makes a person who they are. However, they can be helpful as a guide and a base from which to work. This is especially useful if you have a plot and are designing characters to work with it, or if you have a main character and are thinking about important side characters. However, even if you think you have a firm grasp on who your character is and the type of person they are, it is worth working through the personality types. It can only help you to know your character even better, after all.

One of the oldest analyses of personality comes from ancient Greece, where they believed there were Four Humours of the

EXCITABLE

PESSIMISTIC OPTIMISTIC

CALM

Orthogonal personality types based on the Greek
Four Humours.

It's not enough just to make sure your team has a happy person, a sad person, an energetic person and a calm person on it. People will naturally settle into different roles when working in a group, which rely to a large extent on their personality type but also on the other members of the group and what roles they assume.

Each group has to have a leader, but other members are just as valuable – particularly the peacekeeper, the team member who helps everyone get along together. Other potential roles include the one who comes up with the ideas, the practical one, the naysayer (which can be a very valuable role; a loyal opposition is essential), and the motivator who keeps people going. It's possible, of course, to have one person take on several roles depending on their nature; a motivator-leader is an obvious combination. However, if you have two natural leaders in a group then a fight – not necessarily a physical one – is inevitable, and if you have a leader and four peacekeepers, you may never get anything done.

If your characters are to accomplish something as a group, balancing them is important. If you don't have a mix of roles that fit your characters' personality types, then sooner or later one of your characters will have to act out of character to get the job done. Perhaps that could be part of your story – having a cautious, introverted protagonist forced to lead a team would be a powerful conflict and a drive for character development.

body, which must be kept in balance. These naturally gained associations with the four elements, four seasons, and various star signs, but most interestingly for us, they were also associated with a theory of Four Temperaments. People could be cheerful (optimistic), sombre (pessimistic), enthusiastic (excitable) or calm (phlegmatic). That's not a judgement of their mood at one specific moment, but of their overall disposition; their normal moods and how they typically react to events. A pessimist, of course, will usually take the negative view of an event, and a calm person will not expend great energy on that event whether they view it negatively or positively.

You will notice those are paired opposites, and that someone can be enthusiastically cheerful or calmly cheerful, but not cheerfully sombre; that is, in combination they modify each other, but combinations from just one pair are not plausible. It is perhaps hard to imagine an excitable pessimist, but if you think of someone who spends a great deal of energy on taking a negative view, that's probably close.

Obviously these four categories are very broad, and don't allow for much detail. A person who is angry about something is clearly excitable, but whether to classify them as negative or positive is not immediately obvious.

Someone who had a great deal of influence on this field is Carl Jung, who classified personalities into two broad categories, introvert and extrovert. An introvert isn't necessarily a person who won't talk to others, but rather someone whose overall attitude is directed inwards. They find rest in being by themselves, find their motivations from internal matters and tend to direct their behaviour inwards.

An extrovert is more comfortable with other people, finding the company of others energizing, not draining. They base their motivations on external factors and behave to influence matters outside themselves. Again, these are broad categories and most people are a mix rather than being one or the other. What sort of person is your character? Do they prefer the company of others, or are they happier being alone? You could develop a very conflicted character by taking a naturally extroverted person who had been treated badly as a child; that person might well grow up longing for company and miserable when alone, but afraid to take the steps to make friends.

Beyond the two broad categories, Jung also defined four personality types; two based on how we perceive the world and gather information, and two based on how we judge and make decisions. His perception categories are sensation (detection of

INTROVERT

EXTROVERT

SENSATION

ISOLATED, BROODING: ANTIHERO

SENSIBLE, PRACTICAL: PROFESSIONAL

INTUITION

DREAMER, IDEALIST: ECCENTRIC

DARING, ADVENTUROUS: HERO

Jung's eight main
classifications and
examples of potential
character types.

THINKING

THOUGHTFUL: WISE WOMAN

LOGICAL, TACTICAL: STRATEGIST

FEELING

SELF-CONTAINED: MYSTERIOUS

OUTGOING, EMOTIONAL: CHILD-LIKE

the physical sensations of the world around) and intuition (making guesses at a bigger picture, detecting patterns). His decision categories are thinking (logical reasoning) and feeling (forming subjective opinions). Like the Greek Four Temperaments, each pair are opposites, in that people will lean towards one or the other, which results in eight personality types once introversion/extroversion is considered, or possibly even sixteen, if you add in the orthogonal functions (resulting in a description of a personality as 'Extroverted Thinking Sensation', for example).

Jung's research has been the basis of much more research than can be discussed here; this is a very simplistic summary. It's important to remember that the types he describes are extremes, and in reality people are a mix, and thus so should your characters be. However, if you are trying to balance your mix of characters, or work out what sort of character you need to respond in such a way at a critical plot point, looking at personality types can be helpful.

Past and Present

People are far more than their personality type; we are also the sum of our experiences. How people are brought up can make a big impact on who they will be in the future, and this goes for characters too. The person brought up in a loving home would be very different if they were brought up in an orphanage in a war-torn country. Your character's past is crucial to their

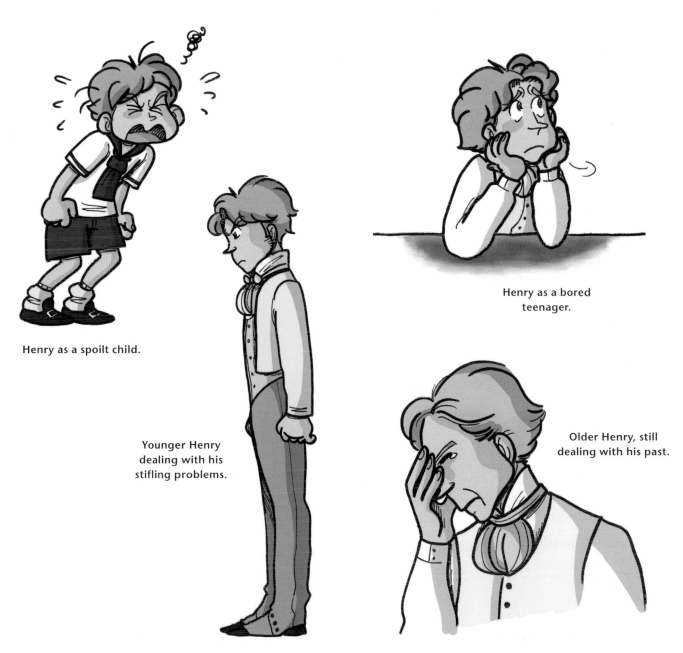

Henry as a spoilt child.

Younger Henry dealing with his stifling problems.

Henry as a bored teenager.

Older Henry, still dealing with his past.

CHARACTER GROWTH AND DEVELOPMENT

As has been stated, characters need to develop throughout a story. This is crucial for telling a believable tale. Just as we are the sum of our experiences, so your characters in the middle of your story will be different from your characters at the start of your story. It is natural that traumatic events will change characters' lives, but even small things make a difference. A short story about starting school and overcoming shyness to make friends can show real character development that will strike a chord with the reader despite its simple premise. Make sure your characters react to what happens with realistic changes, however small, or they will feel unreal and your readers will put your comic down.

present. Don't be afraid to permit your character to have a 'normal' past life, but do make sure you know about it before you start on that character.

Even if not used in your story, thinking about a character's history in detail from childhood to common events, can help build up their present personality even more, and make them more real and interesting. Remember, a believable character is a character that readers can relate to. Who were their role models when growing up? Where did they learn their skills? Who were their friends? Who were their teachers? All these things go towards forming a character.

Here, the character Henry has grown up in a wealthy Victorian family household. As such he is used to getting what he wants, but also craves emotional attention. This will probably make him selfish in the future, and more loud and flamboyant than most people.

When you consider why a character is the way they are, you can gain more ideas for your story and events in it. It may even help fill gaps in your story where you are not sure how to get from one point to another.

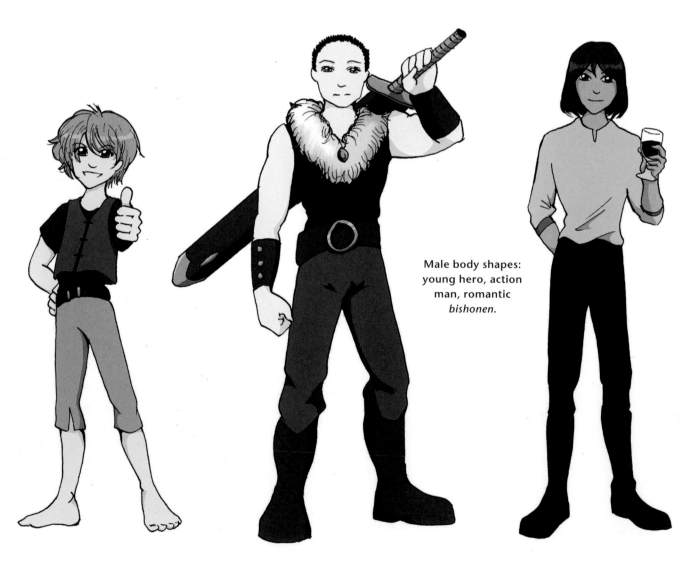

Male body shapes: young hero, action man, romantic *bishonen.*

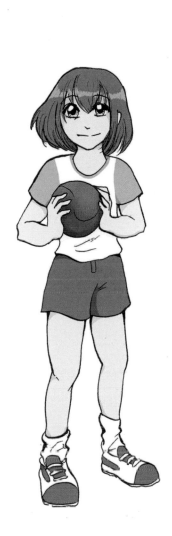

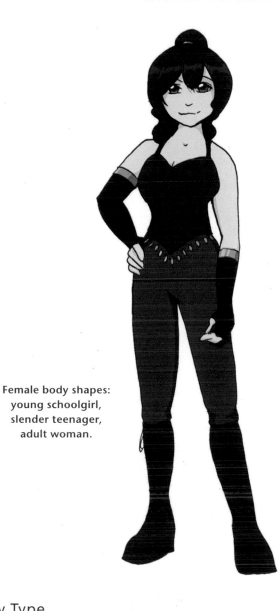

Female body shapes: young schoolgirl, slender teenager, adult woman.

Also think about the little details for your characters. What are their hobbies? What did they enjoy doing as children? Who was their first girlfriend/boyfriend? Are they messy or control freaks? Small information like this can seem insignificant, but will make your character that little bit more personal. The more you know – even without putting it in the story – the more the reader will instinctively understand.

Physical Characteristics

Once you have settled on your character types, you can get to working out what they look like! In reality, of course, you will often develop a character's looks alongside their personality, which is entirely natural. Here are some ideas for character design and tips for making sure your character's appearance fits their personality.

Body Type

A person's body type depends on a combination of their natural build and their regular physical activity; their hobbies and their occupation. Fitting your character's build to their personality and preferences is important, although during the process of coming up with the character you may well find that their body type developed alongside their personality, so the two will naturally fit together. If you are thinking of a tall, brooding swordsman, for example, he is unlikely to have the build of a couch potato. That said, a conflict between appearance and abilities can be an interesting quirk in a character.

Some examples of typical character roles and body types are shown here. A young *shonen* hero will have a boyish build, with the muscles perhaps not yet fully developed. His body type is quite different from the bulky action hero, or the slender *bishonen* character. The cute young schoolgirl, the romantic teenager and the mature woman likewise have different body

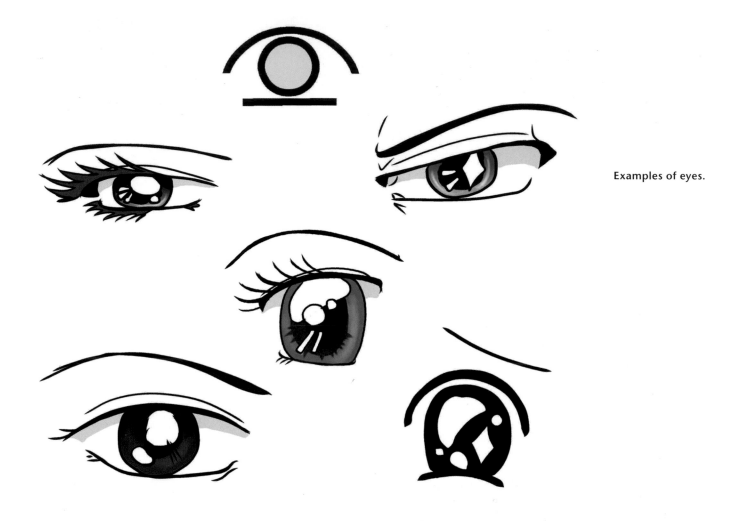

Examples of eyes.

Corbyn's face with emphasis on his eyes.

types. You may find these basic types useful to work from. Which is your character most like? How does he or she differ, and in what way would that change his or her body type? Don't be afraid to experiment with body shapes – having different shapes will distinguish your characters and help immerse your readers in the story. After all, how likely is it that four characters brought together to fulfil a mystical quest would all have exactly the same build?

Drawing Eyes

Eyes are one of the characteristic traits of the manga style. Although there is a wide variety of ways to draw eyes, they are all based on the simple three-part eye (shown above). You can customize your character's eyes by experimenting with the size of the pupil, adding highlights and feathery eyelashes (and yes, male characters have eyelashes too). Typically, the younger the character, the larger their eyes are. Male characters tend to have smaller, narrower eyes than female ones. Narrowed eyes

Hairstyles for Corbyn, each one indicating a different side to his character.

are also a sign of mystery or malicious intention. Don't stick to the traditional eye colours of blue, green, grey and brown – manga characters' eyes can be anything from violet to amber to crimson! Don't forget eyebrows either, as they help to create a wide range of expressions.

Here, Corbyn's eyes have been made slightly cat-like by elongating the outer corners.

Drawing Hair

Hair styles are very important for picking out personality traits, lifestyle and career, and because manga allows almost any hairstyle to go unchallenged by plausibility, taste or gravity, it is worth taking the time to make sure your character's hairstyle is truly individual and suits them. Think about their occupation

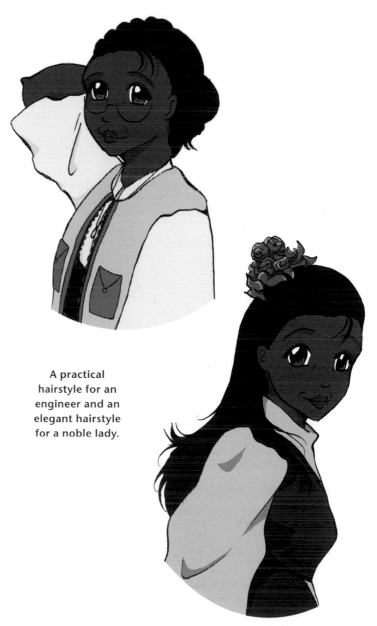

A practical hairstyle for an engineer and an elegant hairstyle for a noble lady.

EXPERIMENT WITH HAIRSTYLES

A change of hairstyle can completely change your character's personality, as well as their look. If they normally have long hair, cropping it short can add a cool, trendy edge to their appearance. Switching from straight to curly hair transforms them into a romantic or fantasy character. Experiment by adding strands of different colours, hair accessories and textures; you can even shape your characters' hair to resemble wings or ears. Hair magazines are good to use as a reference, and you can research hairstyles of various historical eras on the internet.

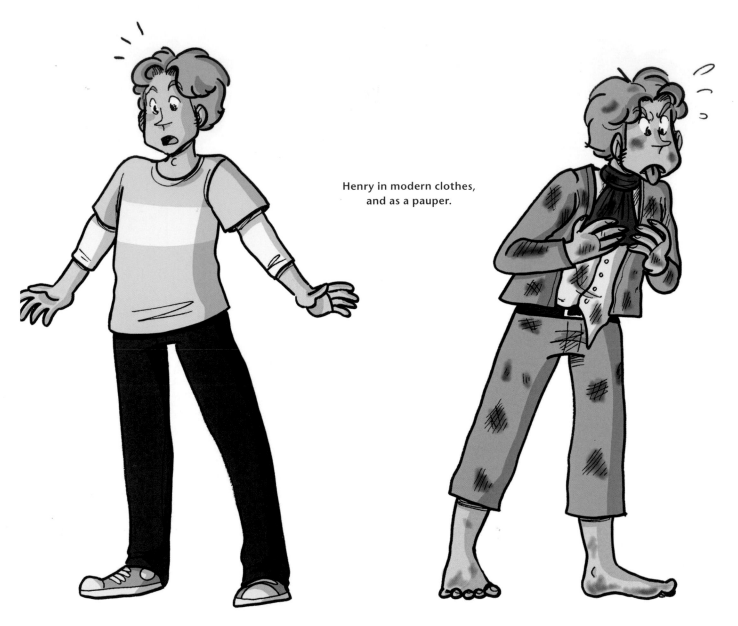

Henry in modern clothes, and as a pauper.

'and what that might require; an engineer is likely to have short hair or tied-up long hair, while a noble lady is free to wear her hair long and loose if she chooses. The setting also plays a part; in some eras men traditionally wore long wigs. Just fifty years ago long hair was not considered appropriate for Western men, but nowadays it's much more common and goes unremarked. If your story is set in an entirely different world, why not add some traditions to how hair is worn; it will add individuality to your setting and your story.

Drawing Clothes

Before you start inventing your character's wardrobe, think about their personality, occupation and what would be appropriate attire for them. An adventurer might wear waterproofs and heavy boots for trailing through forests, whereas a pampered princess would opt for flowing garments and sparkly gemstone accessories. Consider the setting your characters live in too, and their social status. A wealthy man's costume would be completely different from a poor man's.

Choosing particular colours for your character's apparel can also say a lot about their social status. In ancient Rome, burgundy red was a sign of extreme wealth as it was expensive and laborious to produce. The particular 'Royal' shade of blue was created specifically for a (then) British Queen. Plain colours such as grey or muted brown are often seen as markers of austerity and modesty. Colour choice also shows a great deal of the character's personality. White, for example, gives an impression of innocence. Black is malice or mystery, whereas red is a sure sign of an attention-seeker!

Researching your characters' clothes is one of the most enjoy-

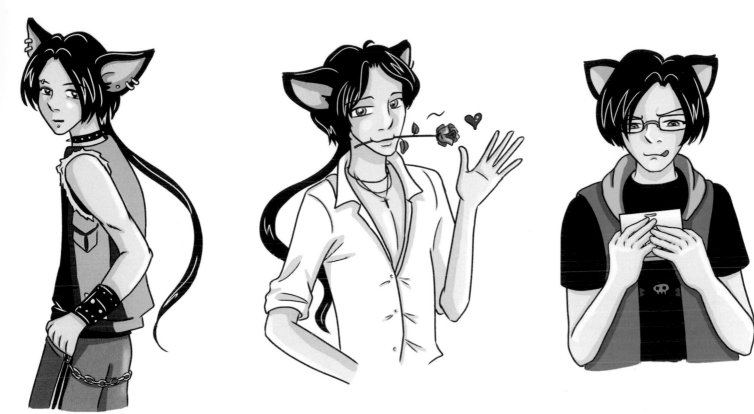

Corbyn could look trendy, romantic or geeky, depending on how he dressed.

able parts of character development. Take inspiration from fashion magazines, or clothes people wear in the streets. You can start a scrapbook for your character, where you can keep photos, magazine clippings, and note down ideas to try out. If your story takes place in a fantasy realm, you can base the characters' clothing on a particular epoch – the ancient Greek, Roman, or the Rococo and Victorian eras are particularly great sources of inspiration. Research books on costume, or attend history-themed events such as medieval fairs. Otherwise, inventing your own hierarchy and rules for what's appropriate to wear is great fun!

If your character normally appears wearing only one costume, such as the school uniform, try to think how dressing them in different things would reflect their personality or interests. In the example above, you can see how Corbyn changes from trendy to romantic to geeky, depending on what clothes he's wearing.

School uniforms are extremely popular in manga and anime. If your story is set in a high school environment, you may think it is difficult to express your characters' personality traits. But although all students of the same school have to wear the same clothes, it does not mean that they become clones of each other. In real life, each school uniform, however strict, incorporates some degree of variety. Girls, for example, can wear trousers or skirts. Winter uniforms are different from summer ones. There may be separate uniform sets for special occasions and everyday

use, or differentiation between older and younger students. In addition, a character's personality also shows through the way the clothes are worn – your character may have his or her unique way of tying a school tie, his/her sleeves may be habitually rolled up, he/she may wear her shirt collar in or out of the school

EVERY DETAIL COUNTS

Remember to always use references for objects, especially if you are setting your story in the modern day, or a historical period. You may think you know what an item looks like, but attention to detail and consistency will set apart a great manga from a good manga! Even if making a fantasy, draw out designs for accessories beforehand so that they are consistent throughout your manga. You may even want to use references from real life objects to inspire your own inventions. Referencing is especially important for mechanical objects such as firearms or vehicles, where you may not know how something moves or is held unless you look at it properly.

LEFT: **A pocket watch, given as a romantic gift.**

RIGHT: **A pocket watch, now a mournful reminder.**

jumper. You can give your characters their individuality through accessories that look unique to that person but still fit into the dress code, such as bright or stripy socks, jewellery and hair accessories. As you can see, even in areas that may seem restricted at first, there is a great scope for characterization.

Drawing Accessories

Accessories can be used as both a visual tool to push a story along, and a way to add quirks to a character. They are helpful props to enhance minor characters who don't get much time in a story, but whom you still want to make visually entertaining for the reader. On a more complex level, accessories are a great tool for symbolism or as plot devices if you don't want to reveal something in a story through dialogue.

Keeping an accessory from an earlier moment can be used later in the story to remind the reader of a key point without being too obvious. It can also be used as a way to intrigue readers or make them question characters' motives.

Colours

Manga may be commonly black and white, but your characters inhabit a colourful world and it's good to plan their colour themes, both for their own natural colours and for the clothes they like to wear. As has already been mentioned, colour can indicate a lot about a character – and you can get a lot across even in a black and white comic. A character dressed all in black immediately looks sinister; perhaps he is a villain. Or on the other hand, perhaps he is the anti-hero type, for whom black is practically a uniform! Warm colours, reds and browns, can indicate humour and warmth in a character, but more violent colours could show a character's short temper.

Red hair is particularly commonly associated with a fiery,

volatile individual. Cold colours, on the other hand, could indicate detachment, a general coolness towards people. Combinations of colours across different characters can also be indicative – opposing characters may have opposing colours; pale versus dark, for example. A blond character who wears black would be well offset by a dark-haired character dressed in pale colours.

If your comic is monochrome, then the only chance you will have to show off your character's colours is on the cover. Use it well! But consider also the effect of rendering your colourful character into black and white. If you have a blond girl dressed in a pale blue blouse and blue skirt, that could end up looking like a girl dressed all in white, with white hair. Obviously people are used to interpreting white hair in a monochrome comic to be pale hair, perhaps brown or blonde, but the overall effect will be a bleached, uninteresting character. Add some 'colour' to your character with black accessories, black socks for example, or a dark blazer. Or even change the skirt to a dark blue, so that it ends up black in your comic pages. Having a mix of shades will make the character more interesting to look at and will also make her stand out. Of course, there are exceptions – a character intended to be the archetypal innocent is probably best left in white! Keep in mind what your character looks like in black and white while choosing their colours, because they will need to look good in full colour and monochrome.

Don't simply use tone to compensate for lacking colour. Tone is a good tool but too much of it just makes a page look grey. However much tone you use, you will still need your black accents and your white highlights to make a page stand out.

Depending on local customs, anything could be considered a quirk, such as leaving red hair (unlucky in this culture) uncovered.

Character Quirks

Just as every person is unique, so should every character be. Quirks in a character's personality, habits, or dress go a long way towards making them a more rounded, individual character. Obviously dressing an otherwise normal schoolboy character in a silly hat isn't going to work very well, but making him the kind of person who would wear a silly hat will certainly result in a more interesting character!

Quirks can literally be anything, but consider your setting first; going against the norm in your story might not be something that is odd in the real world. For example, leaving red hair uncovered may not be unusual in the modern-day Britain, but if the setting considers red hair a sign of bad luck, it would be very strange for a redhead not to cover their hair. Settings can impose limitations on characters, that is, a girl who loves pretty dresses is going to be somewhat limited in her wardrobe choice in an Arctic environment, and will have to find other ways to express her dress sense (beads and jewellery, for example). Such quirks are useful because they can bring out the setting as well as the character.

After the setting, consider your character's history. Is there something they might wear for personal reasons? Or something they are afraid of? A boy who nearly drowned as a child might refuse to walk across a river, for example. A girl who trained as a novice priestess might still keep to certain rituals even after leaving.

Finally, consider your character's personality, and what might come out of that. An outgoing girl who loves bright colours might choose to wear a different-coloured ribbon in her hair every day – because her school uniform is a dull grey. A boy who loves to read could make a point of never going anywhere without a book, 'just in case'. These small habits bring out a character's personality and make it unique. Consider your friends' habits, or your own, and adapt them to your own ends.

Designing Android Characters

Making the character you have in your head into an android isn't as simple as making them look like they're made of metal. Androids, even humanoid ones, would not be prey to the normal needs and weaknesses of humanity. For example, Marre in her 'normal' form wears glasses and looks middle-aged, but androids don't need glasses and don't have wrinkles, so an android version of her might look a little worn at the joints instead.

Androids don't need clothes either, so while the human Marre wears a jacket with multiple pockets for stashing equipment in, an android engineer might have tools built into their arms, and storage compartments on the body. The mark on Marre's

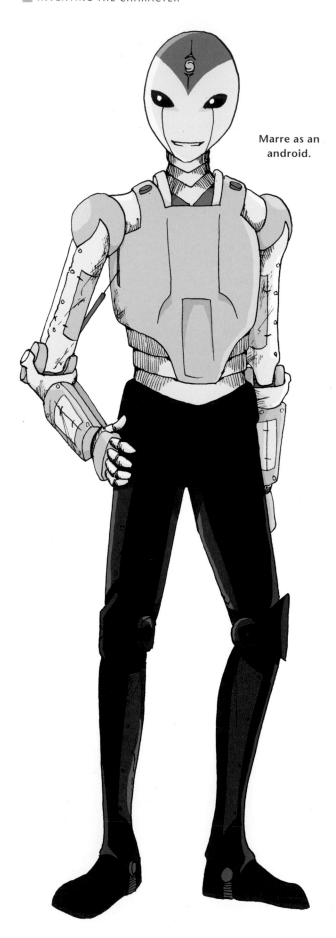

Marre as an android.

jacket could instead have been painted onto the back – or elsewhere. Other things may not need changing. Marre is of an average height and a sturdy build, and it makes sense for a humanoid android engineer to have a similar build.

Creating a Character Sheet

Character sheets are really important as they give you valuable references – think of it as a standard for your character. Having a character sheet also means you have all the information in one place. They vary in terms of information and level of detail contained, but a typical one would comprise several full-body views of your character (for example, front, side and back), several facial expressions (choose the ones your character uses most frequently), and sometimes detailed, zoomed-in drawings of their costumes and accessories. You can use the character sheet to compile a colour palette for the character's clothes, hair and eyes to use as reference.

BACKGROUND INFORMATION

It is a good idea to include background information giving an insight about your character's personality and their role in the story, and details such as their age, occupation, family situation, likes and dislikes. What would be your character's favourite food? What is their ambition for the future? Do they have siblings, or are they an only child? Maybe their family hides a tragic past? Who are their best friends? Do they perform a 'hero', 'villain' or 'sidekick' role?

A person's character is shaped by small details like these, so give them plenty of consideration. Some character sheets also include the character's star sign and/or blood group; in Japan, the blood group is believed to have an influence on human personality and temperament.

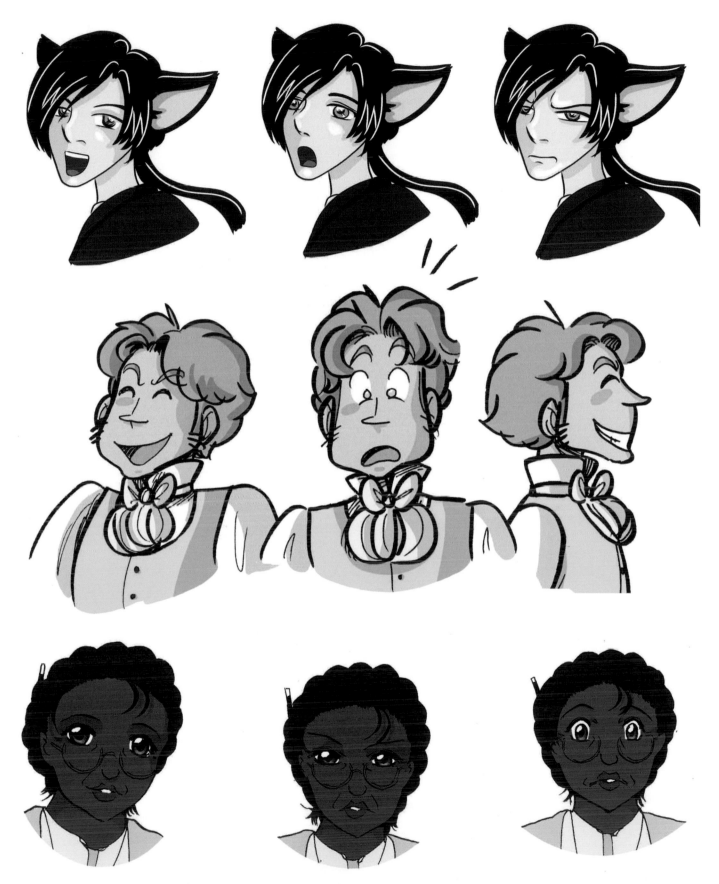

Examples of expressions: Corbyn (top), Henry (middle) and Marre (bottom).

INTRODUCING SIDE CHARACTERS AND MASCOTS

Side characters are, by definition, not main characters; not the focus of the story. However, they need plenty of development too. After all, they are their own person, and the hero of their own story – from their point of view. Unless you are writing a story with just one character in it, you will need to think about side characters, and they can be very useful, driving the plot or providing information at the right time. They can play a pivotal role in creating a protagonist, often helping shape them, and providing them with help and support in their weaker times, or a challenge to their strength. Never underestimate the usefulness of a considered mascot! Side characters can also provide much-needed comic relief in more serious stories, and vice versa. Side characters fill in gaps for roles unfilled by lead characters and have the potential to widen your reader audience.

There are many ranks of side characters, as some characters can be more minor than others. There is a difference between side characters who stand alongside the lead character, and side characters who are only seen once every few chapters. You need to carefully consider the design for both types, but of course more attention needs to be paid to those who appear more often.

How to Develop Side Characters

In many ways, side characters should be developed in exactly the same way as the main character. They are just as much an individual personality, and in an ideal world they would get as much development and thought put into their characterization. However, they are also subject to the story and the main character in ways that the main character is not.

In Chapter 5, the two ways of developing character and story were discussed; thinking of the plot first, or thinking of the character first. Either way, the side characters can end up suffering from being placed last. If you think of your plot first, the side characters and main character will often be developed together, and the challenge remains to make them believable charac-

ters whose genuine personalities will drive the plot you have already laid out. If you have your main character and then think of a story in which he or she can star, the other characters can end up sidelined, being flat creations who exist just to make the main character look good. Your job is to make them fit into the story and into their place in it, and make them believable characters.

Types of Side Characters

There are several different kinds of side characters, including background side characters, occasional side characters, temporal side characters and companion side characters. Even antagonists, often a crucial part of the story, could be considered to be side characters.

Background side characters are those people who have to exist in the world in which your story is set. Examples include parents, shopkeepers, classmates, teachers – people without whom the world would be unnaturally empty, but may never say more than 'hello', or 'settle down, class' or 'dinner's ready!' The motivations of background characters often don't need stating explicitly, since they are understood by the nature of who they are. They don't even need names. Be careful, however; the moment you use a background character to do anything unusual for the type of person they are, they will need development. The teacher who stays behind to make sure a child isn't bullied on the way home from school ceases to be a background character and becomes a side character, even if a very minor one. Why did they do that?

Occasional side characters are the ones who show up once or twice, who make an impact on the story and characters but are not permanently part of it. Sometimes you will need a character to drive the plot forward, and none of your main characters will do. Perhaps your main character is a detective, and she needs to find out a vital clue that leads her to the next phase of her investigation. An easy way to do this is to have a side character bring up something which they have no idea is important.

Almost every story has one or more side characters to accompany the main character.

How did they find out that information? Why did they mention it to the detective? These things are important to consider. Try not to bring characters in just to do the necessary plot-propelling – if you need a character to do that, make them part of the story as early as possible, even if the rest of the time they are just background.

Temporal side characters are those who are no longer in the story now, but whose actions in the past heavily influence your main character. They can be minor or major characters in the story, and require appropriate levels of care in development. Obvious examples include deceased or absent parents and former teachers. Although they are not themselves active in the story, their influence is important to consider and their words and actions, as seen through the recollections of the main character, need to be consistent. For example, if your warrior character remembers he was taught always to wait and watch an opponent before attacking, it would be inconsistent of him to later think that his teacher instructed him to shoot first and ask questions later. That can of course be an important plot point, particularly if two characters, taught by the same person, have differing recollections.

Companion side characters and antagonists need the most thought and care. They will often come to mind naturally as part of your hero's story, but because they play a major role in driving the plot and in character development, their motives and decisions need to be considered as carefully as your main character's. They should complement the main character without overshadowing them.

Marre as a main character with her friend Toby as a companion side character and an old friend from the army as an antagonist. Her apprentice is an occasional side character, and her long-dead love a temporal side character.

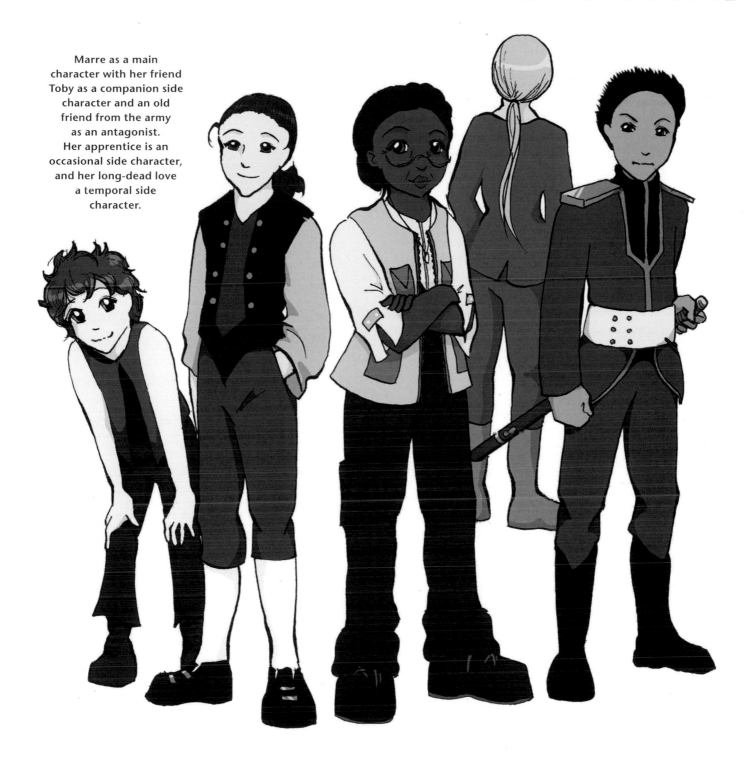

Thinking up Side Characters

Background characters often come to mind naturally as part of the setting you have designed. Think about the people who live around your main character, the kind of lives they have, the kind of people they will be. Look at the people around you for inspiration. Although side characters are just background they are still important; an under-populated world will feel

unreal, unless that is an intentional part of the setting. Try not to let their appearances become generic – each one is a person in its own right – and although they may not be important in your story they are in their own. They need to look as if they are individuals.

Occasional 'side characters' are often born from background characters, but they need more care than might first be thought. They must not be obvious inserts, there to propel the main

character to the next plot point. Reusing occasional characters rather than introducing new ones all the time is a good way to control things, but if your occasional characters show up more than once take care that their character and actions remain consistent. If your plot requires your fantasy hero to be imprisoned after defeating a monster, and you choose to have the king both command the defeat of the monster and then order the hero to be locked up, there must be a good reason for the king's change of heart.

Temporal side characters can also be based on background characters; that is the people who might be expected to have existed in your main character's past. They need to have had a reason to be involved with your main character, of course, and that reason and the actions and words remembered by the main character should all be consistent. The care required for temporal character development varies depending on how much they influence the main character and the plot.

Companion side characters and antagonists will often develop alongside your main character as a necessary part of the story. Be careful to consider them as their own people, however, and not as detached bits of the main character. They need their own motivations and reasons – this is particularly true for antagonists.

Companion Side Characters

How can they be Important without Overshadowing the Main Character?

Side characters need to be unique in their own right, while keeping the main character's presence the most important part of the story. The main character should drive the action in the story, but the side character should be there to supplement the action, and possibly guide it. If your companion side character can be eliminated from the story without damaging the progression of the plot, then their role needs to be reconsidered. On the other hand, if your side character gets more panel time than your main character, perhaps their roles should be switched!

Mentor characters are an obvious example, but another good example from magical girl/boy manga is the 'normal best friend' character. This is a character who is the best friend of the hero or heroine who acquires magical powers, and while they may know their friend's secret and support them, they will not gain powers themselves. Without them and their encouragement and advice, however, the hero or heroine may never succeed in their quest.

A good example of effectively using a multitude of side char-

MORE THAN THE SUM OF THEIR ROLE TYPES

Remember, your main character does not have to be a hero-type character. For example, in a fantasy quest story it is common to find a sword-swinging hero in a party of adventurers. He or she will probably be accompanied by several other people: more fighters, a mage, or a bard-type character. But the sword-swinger does not have to be the main character. Perhaps the mage is the main character and this is a coming-of-age tale disguised as a fantasy quest: she is on her first job since leaving her teacher and her small home town. Perhaps the main character is one of the other fighters, who has come out of love for the hero, and the story is primarily romantic despite the fantasy quest setting.

The character roles, side character types and plot types we have described in this book are just foundations or skeletons for you to base a story on. If you think through and past your chosen genre and your chosen character types, you could end up with a much more interesting story with complex, well-fleshed out characters that will live on in your readers' minds long after they've finished your manga.

acters in the story is the manga and anime series *Naruto*. There are literally dozens of characters of different types – antagonists, sidekicks, best friends, love interests, and mentors. However, each of them possesses distinctive personality traits, looks, and abilities that keep them from blending into the background. The characters' quirks, such as Kakashi's mask or Rock Lee's orange legwarmers, appeal to the audience and make the side characters just as likeable and popular with the fan base as the main ones.

How can they Complement the Main Character?

Side characters should share some attributes with the main character(s) while still differing in other ways. The similarity can be as simple as living on the same street, or as complex as being siblings. After all, if a side character is entirely different from the main character in every way, then there is no interaction

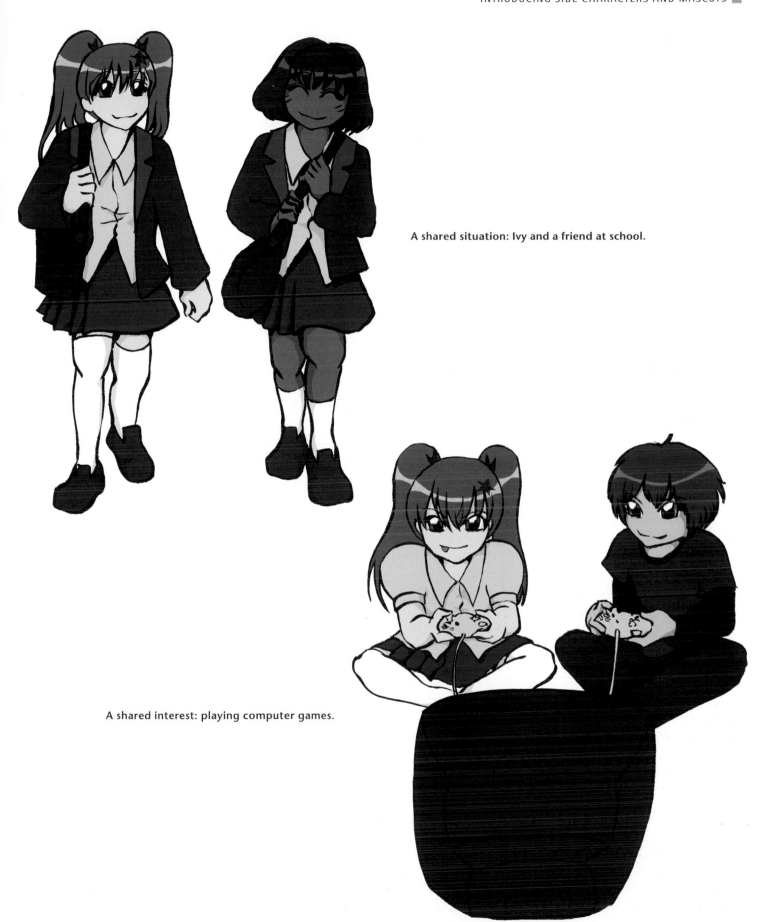

A shared situation: Ivy and a friend at school.

A shared interest: playing computer games.

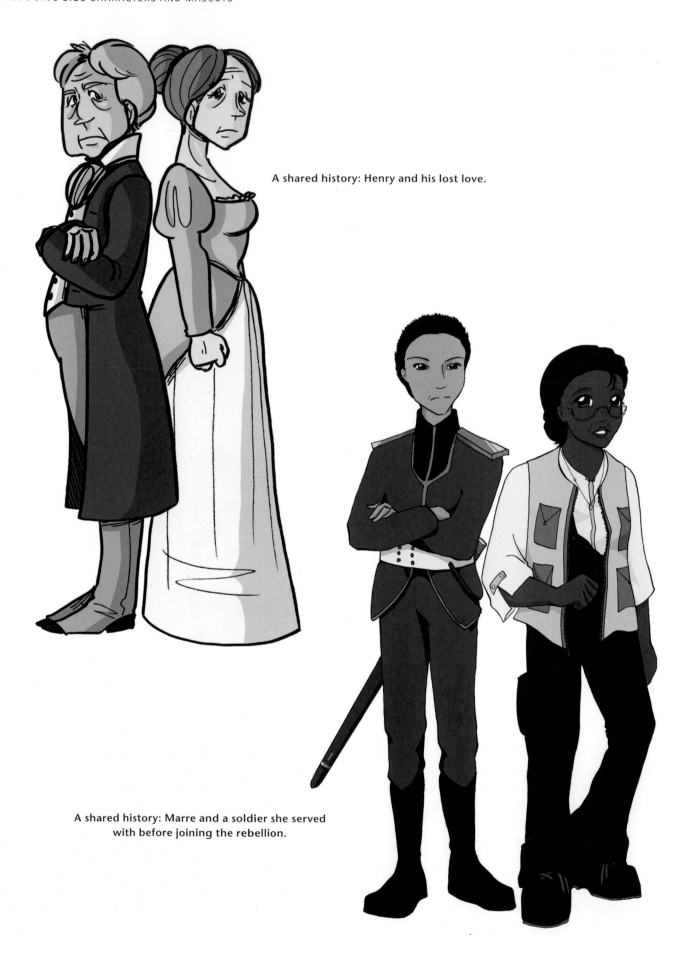

A shared history: Henry and his lost love.

A shared history: Marre and a soldier she served
with before joining the rebellion.

You don't need a huge number of characters to tell a story well.

possible, and if they are entirely identical, there is no point having them in the story. Characters are tied together by their similarities, but the interest in their interactions is born from their differences.

Many things can unite the characters, such as hobbies, certain personality traits or their childhood. Perhaps there is an insignia or pattern that both side and main characters favour, which can tie them together visually. Maybe they share a common goal (typical in a quest-type story), or have found themselves in the same place by chance or design. A shared past history can make for a very intense drama.

The same things that could unite the characters – history, personality, goals – could also be where they differ. Take the time to consider what your main character needs. In which areas is he or she lacking, and in what ways could a side character make up for that deficit? Perhaps they share a common history but differ in their personality or ways of approaching a problem. Perhaps there are many characters of different backgrounds and personalities in a situation that is new and unusual to them all – in this case, they share their situation and possibly an aim, but differ in just about every other respect. Many fantasy storylines

are based on this principle. A crime story might feature a detective and a murderer who share a history and situation, but have very different aims.

Choosing Companion Side Characters

When choosing companion side characters, remember how important it is to differentiate them from the main character. They should complement the protagonist rather than outshine them. Give them qualities and features that your main character is short of. For example, an impulsive hero would be counterbalanced by a calm, reserved best friend or mentor figure. The contrast between the characters and the dynamics of their relationship will add depth to the story.

Do not overload your story with side characters. If you are creating a short story, go with linking a maximum of three side characters to each main one. For example, a best friend, an obvious (or secret) love interest and an eccentric mentor would be sufficient to complement the protagonist. Side characters add interest and variety to a story, but the more characters there are,

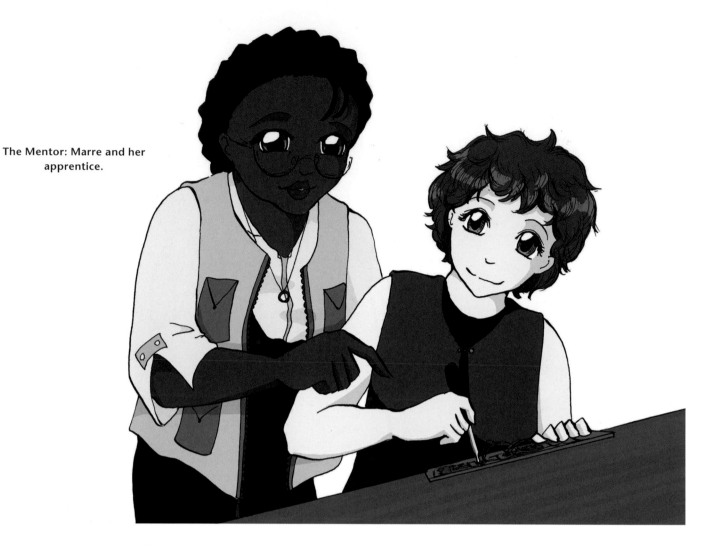

The Mentor: Marre and her apprentice.

the more confusing it is for the reader, and the more skill is required to make each distinct and memorable. If your side character never does anything that drives the story forward, it is worth thinking seriously about whether he or she is needed.

often have a lot of knowledge and wisdom at their disposal, and can sometimes lose their temper with their inexperienced student. The Mentor character will have few fatal flaws, but for instance, perhaps their age is a hindrance and produces physical or mental obstacles.

Side Character Roles

Character roles have already been discussed (Chapter 3), and most side characters will fall into one or another of those 'boxes' – although as always, don't feel constrained by the roles. Feel free to mix and match types to make the side character you need.

The following are some examples of common side characters.

Mentor

The Mentor is there to help guide the main character through the story and to support them when they need it most. They

Best Friend

The Best Friend is exactly that – the main character's best friend! This character has the potential to be the most varied, as the Best Friend can afford privileges the Mentor cannot. As well as their own flaws, the Best Friend can have very different aims from the main character (which the main character may or may not be aware of), which can help drive the story.

Rival

The Rival is similar to, but distinguishable from, the Best Friend. The Rival is there to help spur the main character on. Perhaps

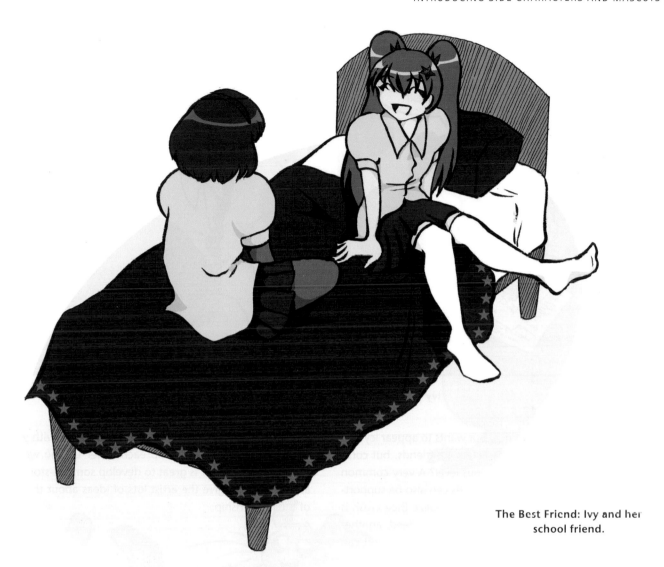

The Best Friend: Ivy and her
school friend.

The Rival: Henry and
his nemesis.

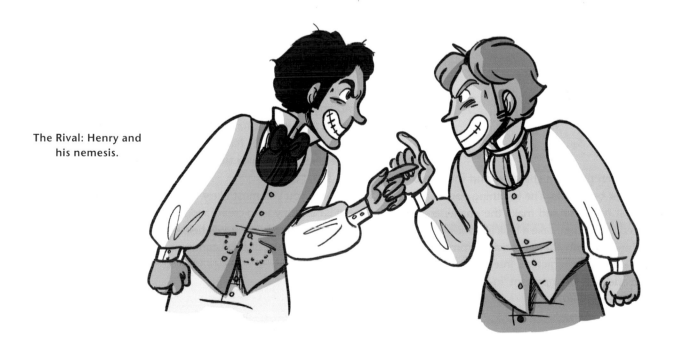

CHARACTER BREAKDOWN

Developing each character is a long and complex process, but it is real fun too! In this chapter, we have described our characters and explained how we came up with them. Everyone works in different ways; there is no such thing as a right or wrong way to come up with characters or stories – and the more you create, the more you'll be able to figure out how you manage to do it best. Within this chapter you may be able to find ideas and inspiration on how to begin the process of fleshing out your own characters.

Ivy

A sixteen-year old girl with a lot of dreams; so many in fact, that Ivy's dreams are capable of predicting the future! Armed with her dream 'friend' Marcus, the two explore the future in Ivy's mind, trying to discover a way to avert a major disaster!

'I came up with Ivy on my train journey to work. I myself have a very active imagination, and to pass the time I often imagine things happening outside of the train. It was only when I thought about this a little more that the idea of predicting the future popped into my head too! And then Ivy was created. It's funny how ideas come to you so quickly like that.

'Ivy's dippy expression sums up how I think she feels about life. She has such a talent for imagining things that she is almost always on the lookout for new things! Her mascot Marcus had to be a totally

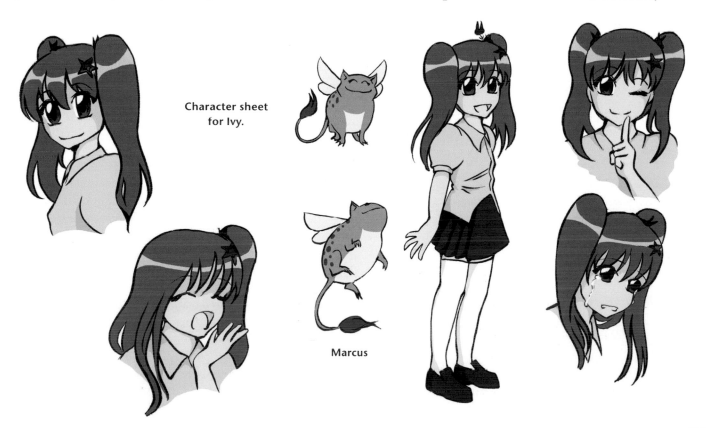

Character sheet for Ivy.

Marcus

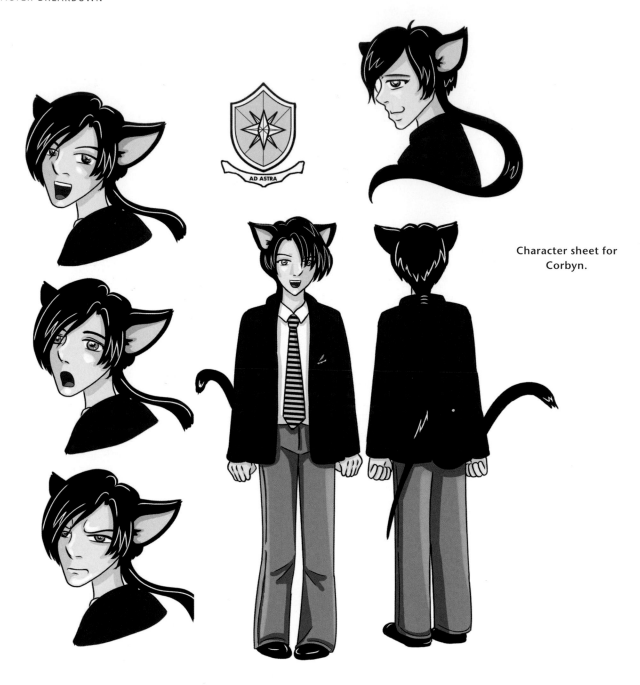

Character sheet for
Corbyn.

imaginary creature; light on his feet and yet fat-looking! I always like mixing contradictions up in a design – it makes things feel intriguing.' **Ruth**

Corbyn

Corbyn is fifteen. He may seem like any other popular teenager at his school... apart from the fact that he is also a catboy. Those ears and a tail can be both a help and a hindrance!

'I wanted to create an unusual character that would exist in a completely ordinary setting, so the idea of a

catboy in a school was born. Corbyn is a protagonist in the story; witty, popular and respected by peers, despite his looks. He has a reputation of being a bit of a class clown, which is frowned upon by teachers – until they crack up laughing. Corbyn is especially loved by girls for his feline charm, that is, until he comes across a girl that is really not that much into kitties… Corbyn has experienced some bullying when he was younger, but he hides these mental scars well under his outgoing and sociable personality.

'Corbyn's look is partially based on my cat. I experimented with different coloured ears and hair before deciding to make them both black, for a sleek

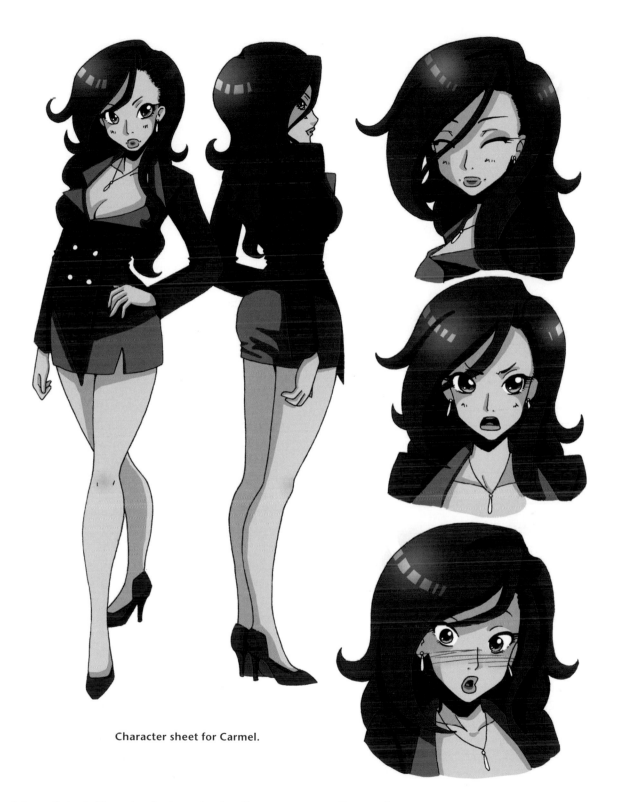

Character sheet for Carmel.

and dramatic look. I love developing school uniforms and enjoyed inventing Corbyn's. Originally, I pictured him wearing a vest with the school logo, and trainers to show his 'rebel' side, but then opted for a blazer and black shoes to make him look more formal.' **Irina**

Carmel

Carmel is the epitome of success; head of her own company while still young, besides being ambitious, beautiful and intelligent. But her passion and position could also be her downfall – what will happen when a rival appears?

Like any skill,
character design
and development
improve with
practice.

'Carmel does however, have a competitive side. She is usually very collected and professional until there is someone who might usurp her position at the top of the beauty industry. Blinded by the competition, her professional mask falls and it becomes truly evident how passionate she is about her work. Her company is everything to her; she has worked all her life to share the products she created with so many people and make her company into an industry leader. When this is threatened she will fight to keep it at the top.' **Chloe**

Henry

Henry is the son of a wealthy aristocratic family. He thinks he's got it pretty easy! That is, until he falls in love. Now Henry will have to face the fact that when it comes to social rules, he can't always get what he wants...

'I'm a big history geek, so my main drive towards creating Henry was wanting to explore the very unusual world of Victorian society. Henry is a character born from looking at all the customs of that time, and putting all of its rules and opportunities into one character. Henry is like a textbook aristocrat; he has all the traits, problems and freedoms of an upper class Victorian. But they were such interesting people that plenty of personality and story opportunities grew from making a character based on historic fact.

'Visually I have been very careful to make younger Henry wear the latest fashions of the time. He is indulgent and only ever wants what's best; this means his fashion has to be the best of the best too, especially if he wants to impress the ladies! Even his hair and sideburns reflect the fashionable haircut of the time.

'However, older Henry wears similar clothes to his younger self. I wanted to show how he becomes fixated on the past and very bitter – this shows in his growing disregard for spending money or keeping up appearances. An old man unable to move on from what he once had, Henry is only interested in wearing the kind of clothes he wore in his youth. Henry changes a lot in personality as he gets older. His younger self is energetic, sociable, and a bit naughty. I draw him moving around a lot and being very over the top, as he likes to enjoy life to the fullest. As an old man Henry is much more reserved and tries to keep himself under control, I normally draw him hardly moving at all, and always with an unpleasant scowl!' **Rebecca**

'I wanted to create a female character that was passionate, confident and powerful. A leader of a company who has good intentions, but who could make bad decisions due to how emotionally involved they are in their work.'

'Working in the beauty industry means Carmel has to be receptive and tactful when it comes to people's needs. After all, a person's appearance can be a very sensitive issue. Her business model is moulded around making people feel good about themselves first; this happiness in turn makes them appear better on the outside. Carmel knows that face creams and make-up won't fix everyone's woes, but she does know that when people use her products, they feel amazing. Her wish to share that feeling with as many people as possible is what drives her to keep pushing her company to new heights.

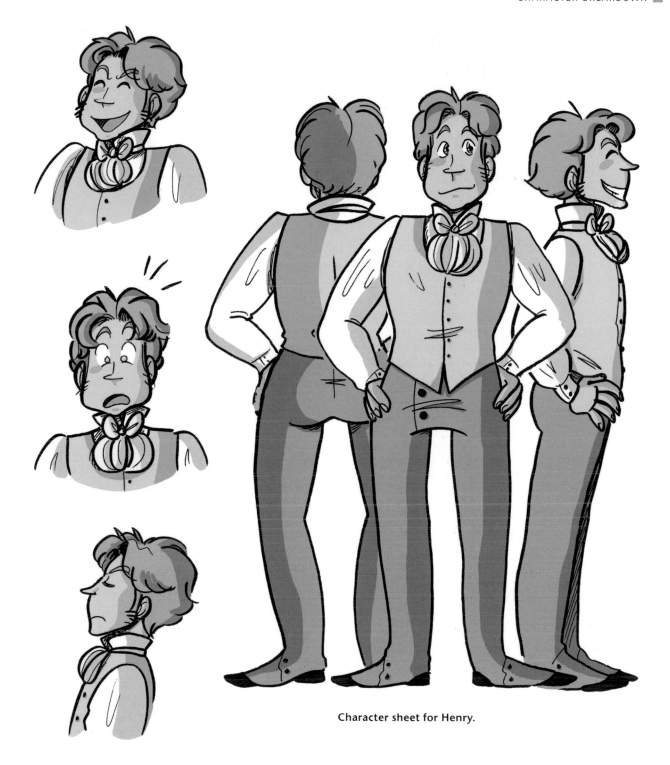

Character sheet for Henry.

Marre

Marre has not only lived through a civil war, she fought on both sides. Since the signing of the Great Accord, she has made peace with her history and a new life for herself working as an engineer and inventor. But the past does not lie easy, and her part in the fighting has not been forgotten.

'I wanted Marre to be a character who was not obviously a 'main character' type; she's not young, and has been through a lot in her life. Of course, this doesn't make her unsuitable to be a main character, but it does differentiate her from the common image of a protagonist. A middle-aged character needs some way of earning a living, so I chose engineering. As well

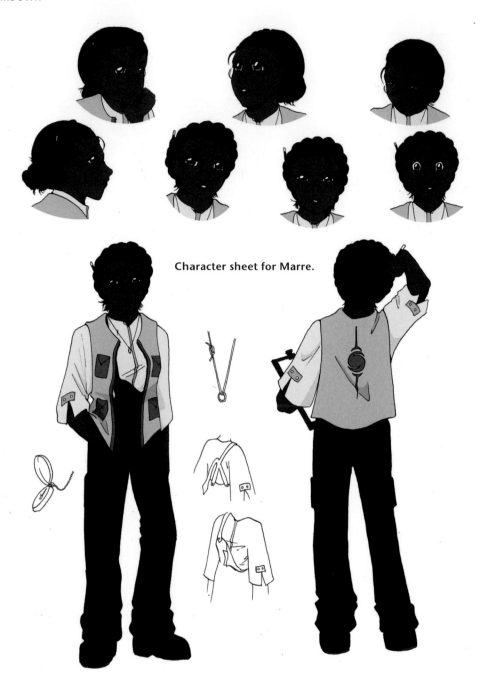

Character sheet for Marre.

as being in the kind of job that would fit a multitude of settings from fantasy, to steampunk, to alternate history, it's also a less common occupation for a female character, and I like to break stereotypes.

'I also wanted her to have an interesting history – this is part of the joy of an older character! Armies, war and rebellions are common to multiple settings, and offer many options for an interesting backstory. I have left her history mostly open at this point, with only the major details laid out; that she fought first for the army and then joined the rebellion.

'Marre's clothes are chosen to be practical and useful, and her hairstyle is designed to keep her hair

out of the way while she is working. There isn't much about her to indicate a personal history except for the ring she wears on a string around her neck, which was a gift from her lover who died during the civil war, and the mark on her jacket which dates from her joining the rebellion.' **Morag**

Character Sheet Template

Here is an example character sheet. You can photocopy it and use it for your own practice and character development.

CHARACTER SHEET - []

(insert your character's name here!)

Draw your character here:

Notes on your character's background:

Name:
Age:
Occupation:
Likes:
Dislikes:
Family:
Favourite food:
Strengths:
Weaknesses:
Anything else:

Use this space for a colour palette
(eyes, hair, clothes etc.)

Your character's most commonly used expressions:

Character sheet template.

TELLING THE STORY

So far, we have discussed the basics of anatomy and drawing in the manga style, including conveying emotion through facial expression and body language. We've gone over basic character types and what you might need to think about when creating a character, how they fit into their world and the story. We've been through setting the scene, which in itself is almost a character, and needs just as much (if not more) attention to detail. We've thought about side characters and mascots. But none of this is any use without a story.

Ultimately, manga and comics are about storytelling. Even the best artwork in the world won't rescue a bland and uninteresting story.

It is said that there are just seven types of storyline:

- The battle; a fight against an opposing force.

- The quest; a search for something or someone.

- The journey, which differs from the quest in that it's about the journey itself, and how the hero is changed on his or her eventual return.

- Comedy, which doesn't mean a story purely played for laughs but more one based on usually comical misunderstandings.

- Tragedy, in which the hero is trapped by circumstance and his or her own character into an inevitable fall.

- Rebirth, in which the hero undergoes a change in self and must re-adapt.

- Rags to riches; where the protagonist is abruptly moved from poverty to wealth (sometimes metaphorically), and usually has to overcome some barrier to keeping it.

These can be combined of course, but this basically means that whatever story you tell, your readers will have read something similar before. Your job is to make your version sufficiently interesting and individual that they want to read that storyline again.

Your characters, and how interesting and attractive they are to the reader, will play a large part in this.

Character design is a crucial part of making a good story; without interesting characters, the reader won't care enough to continue reading. However, the story itself must also be well-told and consistent, with each section following naturally from what is going on – even if the characters and/or the reader don't yet understand it themselves. Make sure you know what is happening overall – if you don't, your writing will be weak and uncertain. And of course, your characters must act consistently with who they are and what they know. There's nothing quite as jarring as having someone suddenly doing something entirely inconsistent with their established character, or for a character to have some piece of knowledge that he or she

DRAW THE READERS IN

If you start in the middle of the action (in medias res), you can draw in readers immediately and make them want to find out what's going on. However, don't let it go on too long without offering at least a partial explanation as to what's happening. One way to do that is with a flashback to explain how the characters ended up in that situation, but these need handling with care – they can easily become walls of text in an effort to get it over with quickly and get back to the action.

Another option is to start your characters in a less important scene – a minor battle for example – which can be explained quickly in a few words once over, before the preparation and explanation of the main plot events.

A page layout with panels of varying sizes. This page would be read at a normal speed.

shouldn't have known. It makes the reader aware that they're reading a (badly told) story, makes them question motive and characterization, and breaks the narrative flow.

Panelling and Page Layout

On a more practical and very manga or comic-specific note, page layout is enormously important for your storytelling. One of the crucial differences between manga and Western comics is that very distinctive look of manga pages. While Western comics tend to have a much more regular pattern regarding the size and shape of panels (or boxes) on the page, manga allows

A page layout showing small and diagonal panels (top) and a full bleed panel (bottom). The diagonal panels would be good for a fight or an accident; the full bleed panel could be showing the aftermath. The reader would start the page reading quickly, but the full bleed panel would slow the pace down.

a lot more variety and scope. The way the action is divided and arranged on a page in panels is called page layout. It is often seen as secondary to the artwork itself and is easily disregarded. In actual fact, a good layout can make even an average story more visually appealing and more engaging to read. By changing the size, shape and appearance of manga panels, you can achieve visual effects that would enhance your storytelling and make it more attractive to the readers.

The first thing to consider is the number of panels on your page. Do not attempt to cram too much into one page – it's not how many panels there are on the page that's important, but what you put into them. A maximum of eight panels per page is normally recommended – anything over that, and you risk confusing and overwhelming the reader. You can combine different-sized panels on the same page. Larger panels would naturally attract the reader's attention, so use them to set the

OPPOSITE: **Page layout with different types of speech bubbles. Notice that even if the panels are taken away, the speech bubbles would still be read in the same order. This sort of planned layout, while not always possible, makes the page intuitive for your readers.**

scene (for example, they can contain a detailed picture of the character's surroundings or setting) or emphasize your character's feelings or actions (for example, a close-up of the character feeling upset).

Box panels are the most common type, and are what most people think of at first. Small box panels can give a sense of speed, encouraging the reader to race through them, while larger ones will slow the reader down. Use different sizes to guide reading speed, but even when a page is to be read at a single speed, try and vary your panel sizes. It engages the eye and creates background interest on the page.

Panels are typically seen as boxes, but in fact can have various shapes, depending on the pace of the story, the genre, and the type of narration. Try using diagonals, for example, to create the right atmosphere. The combination of panel sizes and spaces between them (called 'gutters') can set the mood and regulate the reading speed for the whole story. Use an irregular shape to make the action appear more dynamic, and to set a quicker pace to the story. A page full of jagged diagonal panels won't work very well for a calm scene, but would be ideal for a fight or an accident. Wide panel gutters give an impression of the action happening at a slower pace.

A panel does not necessarily have to be 'boxed'. On the contrary, an unboxed panel can be a useful placement for an 'aside' comment or an addition to the main narration. You can also use a larger unboxed panel to introduce new characters. A borderless panel which stretches off the page (known as 'full bleed') can give a sense of timelessness. The scene it contains continues before and after the moment the reader sees. These panels are useful for setting a scene, or establishing an emotion.

Breaking out of a panel, on one side or more than one, can add impact to a panel; if your character is in a hurry, or something surprising has just happened, breaking out emphasizes the event.

A full-page panel (when the whole page contains just one 'box') is often used to depict a complex, meaningful scene, or a crucial part of a story. Full-page panels can frequently be seen as chapter openers or final pages.

Sometimes you need to portray a continuous stream of action or sequence for which one page simply wouldn't be enough – and breaking it off would make it too awkward and illogical. This is when double-page spreads can be very useful. By splashing the action on two adjacent pages, you make the story a lot easier to follow and achieve the desired effect.

While you are free to choose panel sizes and shapes that you

feel suit your story best, do not go overboard with them. For example, curved and rounded panel shapes are relatively uncommon in manga, and a star-shaped panel would be extremely awkward to draw in! If you overload your pages with weird shapes they will be very busy, which will make them hard for your reader to take in.

Before you go onto pencilling your page, make full use of a small preliminary sketch (called a 'thumbnail') to decide whether the layout you have chosen is suitable. You may want to try different layouts for the same bit of action to see which one works best. Doing a detailed thumbnail also allows you to plan the scale your characters are going to be drawn in, relative to the size of the panels. A common mistake that is often made is that the characters are drawn too large for the panel – as a result, there is no space left for details such as backgrounds. To avoid this mistake, make sure you outline important details such as the characters' positions in relation to each other, and spaces for speech bubbles, at the thumbnail stage.

When making an expressive manga page, the layout is only half the job; the other more important half is what you actually

DON'T CONFUSE YOUR READERS

You need to make sure your pages flow naturally, so the reader doesn't have to guess which panel to read next. Consider the natural flow of the language: English reads left to right, top to bottom. A native English speaker will look first to the left of the book, top left of the page, then across to the top right, unless their eyes are drawn deliberately in a different direction. The same is true of speech bubbles. Consider how they would look without text or images; which order would you read them in? If the reader has to try and guess, they have broken out of the 'narrative immersion' of the story.

Get someone else to read your pages without art or text. Can they tell which way the panels flow? Which order to read the speech bubbles? Try adding the art but not the text – can your reader tell roughly what's going on? What sort of characters you have? Where they are? What kind of thing is happening, and how it makes them feel? Manga is very much about showing, not telling. Dialogue is very important, but if you can't get a decent sense of your story and characters across without it, you need to rethink your pages.

put in the boxes. The success of your page depends on how you use the layout to enhance the story.

Many novice artists make a common mistake of drawing their characters exactly the same, from the same angle, in each panel. This results in a repetitive, lacklustre narration. Another widespread mistake is drawing close-up shots of characters' heads in each panel, thus filling the page with 'talking heads'. Adding variety to your narration makes the story much more visually appealing. For example, in a scene where character interaction takes place (such as two characters talking), you can depict characters from different viewpoints, focus on the one(s) that are currently talking, show the setting the characters are in, and so on. When you need to depict a character's monologue or inner thoughts, a useful technique often applied in manga is to use large, fairly empty unboxed panels, with just the character's thoughts in them. This layout gives an impression of space and eliminates other visual distractions, so the reader can focus fully on the character's words.

The shape and position of speech bubbles is also very important. In Japanese manga comics, the text orientation is top to bottom, right-to-left, in vertical lines – that dictates the elongated, narrow shape of speech bubbles. Western speech bubbles can be a lot wider as they need to accommodate longer chunks of left-to-right text that is usually centred to make it easier to read and more pleasant on the eye.

As with panels, too many speech bubbles can clutter up the page and make it virtually illegible. A maximum of two or three speech bubbles per panel is a good number to stick to. The shape of speech bubbles can vary, too, depending on the character's mood and tone. The most common speech bubble shape is an ellipse, although other popular types include starburst-shaped ones for the raised or angry tone, or cloud-shaped ones for a cheerful or dreamy conversation or monologue. Sometimes you can even see speech bubbles shaped like a clenched fist, when the words seem to really hit the character!

Creating a successful page layout is a valuable skill that comes with practice – don't be afraid to experiment!

Pacing

The pacing of a story is crucial to engaging the reader's interest. Without good pacing, your story simply won't work. You need to think about which parts should be slow and which should be fast, and vary the pace accordingly. A tense fight between rival spies should read quickly, and the preparation time before the fight should be a transition from slower reading to faster, but the time afterwards when the winner is in the hospital recovering will be slow.

You should also consider where your chapter breaks should

DON'T WASTE WORDS – OR PANELS, OR PAGES

When planning your story, you should aim for every page, every panel and every piece of dialogue to add to the story in some way, even if only a very small one. When you've finished planning, take a break and then look over your work. If you can remove a panel, a page or a speech bubble without losing any impact on the story, does it really need to be there in the first place? Comics take time and effort, so don't waste either on something that doesn't need to be there. Your story will be tighter and better for it.

be, if you are using chapters. Chapters offer an easy way to control pacing; you don't need them, but they can be very useful. End a chapter on a cliffhanger and it will encourage the reader to carry on; end it after a climax and it's a stopping point.

Take as an example the following layout of a fantasy romance story of seven chapters:

Chapter 1: A little princess runs away from her nurse and meets a little boy she likes.

Chapter 2: Fastforward ten years; princess and boy are now teenagers and living normal, if very separate, lives.

Chapter 3: The princess' marriage is being arranged. She dreams about the boy. He is working hard as an apprentice blacksmith.

Chapter 4: The princess meets her fiancé, but she also happens to see the boy. She recognizes him and resolves not to marry her fiancé.

Chapter 5: The princess tries to sneak out and meet the blacksmith's apprentice. It takes her several tries, and when she manages it, he pretends not to know her.

Chapter 6: The apprentice blacksmith goes home and talks to his mother, who tells him to follow his heart. The princess, meanwhile, runs away from home again.

Chapter 7: The blacksmith rushes to the palace, challenges the fiancé to a duel, and wins. But the princess has gone! He races after her and finds her in peril from bandits. He rescues her; they return, marry and live happily ever after.

The pacing in this story is unbalanced; all the action takes place in the last chapter, which, judging from what happens in it, will also be about three times as long as any of the other chapters.

In addition, there's not really any time to find out about the fiancé, so despite being the love rival, he will probably be an entirely uninteresting cardboard cut-out character. We also have no idea how a blacksmith's apprentice learned to duel, nor is his marriage explained – he may have beaten the fiancé, but that is not usually a sufficient reason for a commoner to marry a princess.

There's nothing wrong with the overall story, but to make the pacing work it would be good to change the earlier chapters to contain a bit more each, and to introduce a bit more characterization. Perhaps the fiancé also met the boy when they were young, and they fought. That would add interest and greater conflict to the second duel. Maybe the boy asked a swordsman to train him after the young fiancé beat him – that would explain how he knows how to duel. Perhaps the fiancé offered the princess' hand in marriage to whoever could beat him in a duel as a joke which the blacksmith's apprentice takes advantage of. That could be introduced as early as Chapter 2, which nicely set the scene for Chapter 7.

STORY CHECKLIST

So, you think you're ready to begin your story? Here's a checklist you may find useful, in no particular order:

- Does your story have a beginning, a middle and an end (not necessarily in that order)?

- Do your characters each have a history?

- Do your characters have their own motives for getting involved in what happens?

- Do you have a range of personality types?

- What makes the characters unique?

- How do their personalities show?

- How do they interact?

- In your story, does each decision made by each character make sense in the light of that character's experience and personality (that is, is your character in character)?

- Are your character's clothes and accessories fitting for their day-to-day lives?

- Have you considered the setting, and what it means for your characters, their clothes, jobs and lives?

- Do your characters change and grow as the story unfolds?

- Do you know how the story gets to its conclusion?

- Do all the sub-plots introduced in your story get concluded?

Are you ready to start?

You don't need to know the nitty-gritty of every encounter and every conversation, but the important decision points should have been considered before you start.

Here are some example pages showing the characters you know from earlier. Each page has a script, a thumbnail sketch, the pencilled page and the finished page. These scripts describe what is happening as well as laying out the dialogue. They are not always necessary if you are writing your own manga, but can be very useful as a way to get down the essentials (a crucial conversation or encounter, for example). Scripts do not have to be as formal as the ones shown here – a text file or a page of notes will do just as well, as long as you can understand it.

An Opening Page

This is an example of an opening page in manga, where a character is introduced. From this page, the reader can form an opinion of Corbyn and the impression he makes on other people, as well as some of his expressions and mannerisms.

PAGE WITH 1–4 PANELS

Panel 1
A view of the school on the background, with a close-up of CORBYN walking and waving.

CORBYN: Good morning ladies.

Panel 2
Three girls looking loved-up

GIRL 1: Aaaah!

Thumbnailed page.

The pencilled page.

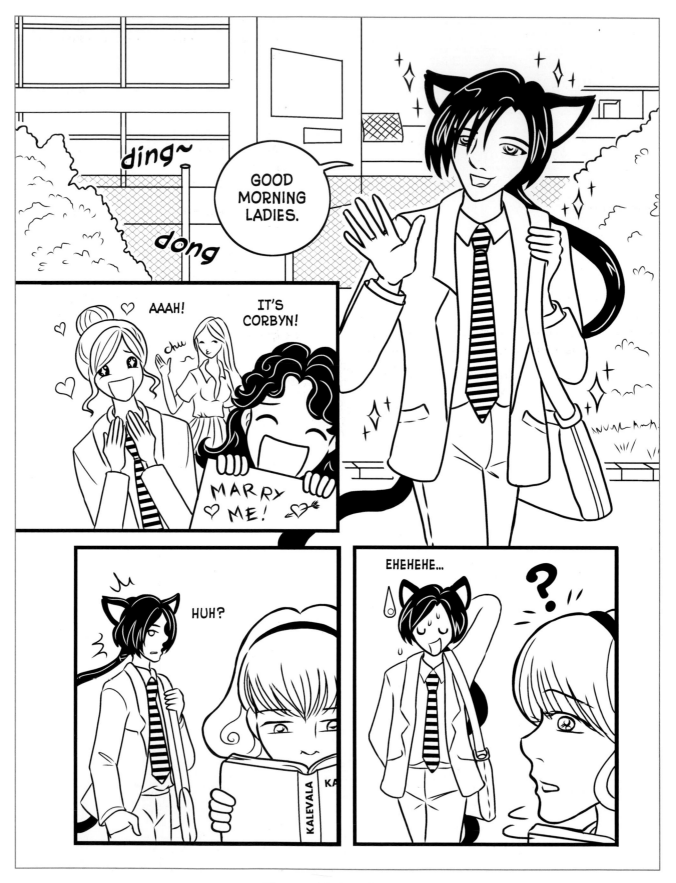

The completed comic page.

GIRL 2: It's Corbyn!
GIRL 3 holds up a sign saying 'Marry Me'.

Panel 3
CORBYN walking past on the background, with MICA absorbed in a book in the foreground.

Panel 4
MICA notices CORBYN, looking confused. CORBYN looks embarrassed.

CORBYN: Ehehehe…

A Challenger Appears

This page is introducing an ongoing rivalry and a new competitive goal. This could be at the start of a new story arc where Carmel has to develop a brand new make-up line to compete with Chéri Rose's Jeune Beauté range. This page also introduces Chéri Rose as a rival. Although she is not pictured, a clear idea of her personality comes through via the message she has sent to Carmel.

There is a knock on the door of the office where CARMEL is working.

CARMEL: Yes, come in.
SECRETARY: Ma'am, a message just arrived for you via a courier…
CARMEL: (opening the letter) Who is it from?

The letter explodes with a cloud of rose petals as it is opened.

SECRETARY: It is from Chéri Rose, Ma'am.
CARMEL: I had guessed that by now, thank you.

An image of the letter being held in CARMEL'S hands; the text can be read. The letter has been finished off with a big lipstick kiss mark.

Thumbnailed page.

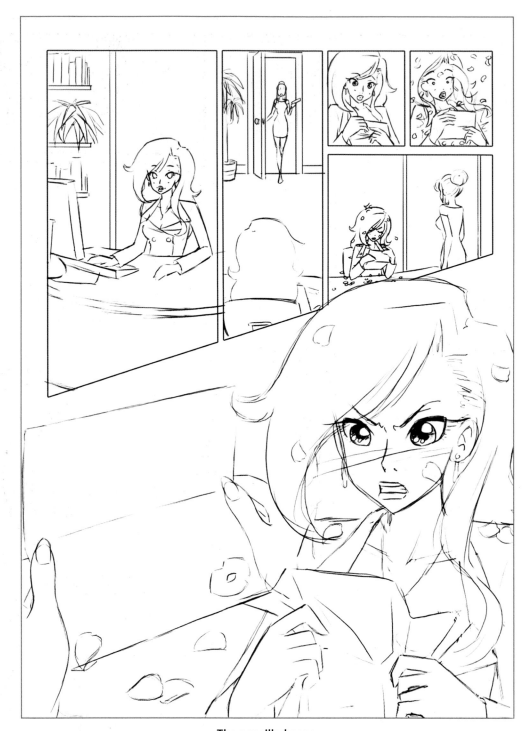

The pencilled page.

LETTER: Hey Carmel sweetie!
Right now we're making the finishing touches to our new Jeune Beauté range just in time for the *Charm Magazine* beauty awards!
 I'll send you some samples after we win first prize, it might help that mature complexion of yours! ♥
Ciao!
Chéri xxx

CARMEL scowls, crumpling the letter in her hands, rose petals still in her hair and on her shoulders.

CARMEL: I will not let her and her cheap excuses for make-up win that award!

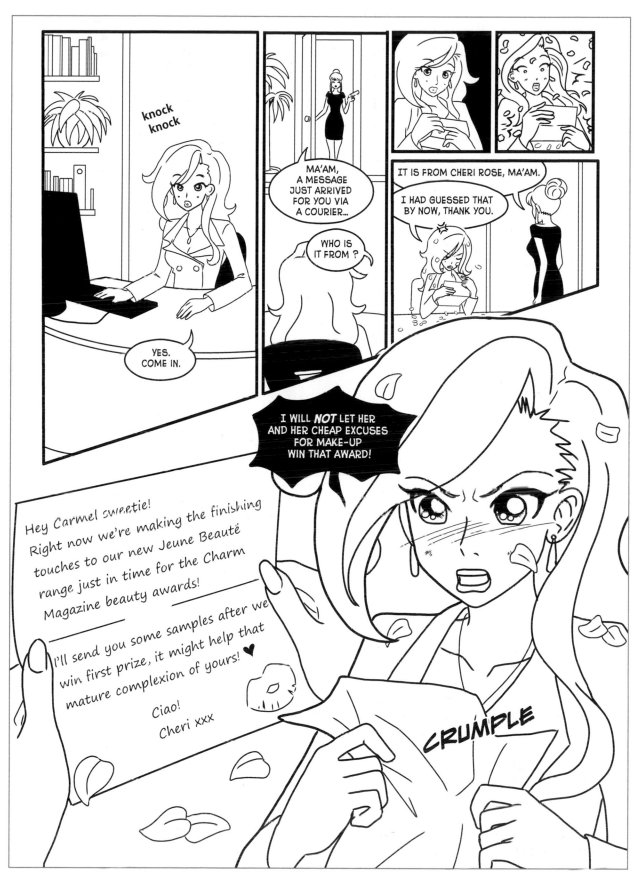

The completed comic page.

An Unexpected Encounter

This manga page is intended to be right in the middle of a chapter; a dramatic moment that would bring everything following up to it together. In order to make sure the visual pacing of this scene gives a good impact, a short summary of the event has been written rather than a complete panel to panel script. This way the panelling can be more heavily influenced through visual planning rather than planning at the writing stage. In this scene panels are used as a way to show the past and present at once, as two characters meet again for the first time after many years, emphasizing to readers the importance of the past story in context with the present.

A woman whose face we cannot see yet has left a letter on the doorstep. HENRY has briefly read the letter, then run out of the door in a flash of anger. He shouts as he sees the woman walking off in distance, then runs down the road to catch her, ready to tell her who's boss. Henry catches up and grabs the woman's shoulder. He is about to shout, but as she turns around he stops dead still. Flashbacks of his past are played as the woman turns around, and we see the familiar but older face of his lost love.

Thumbnailed page.

The pencilled page.

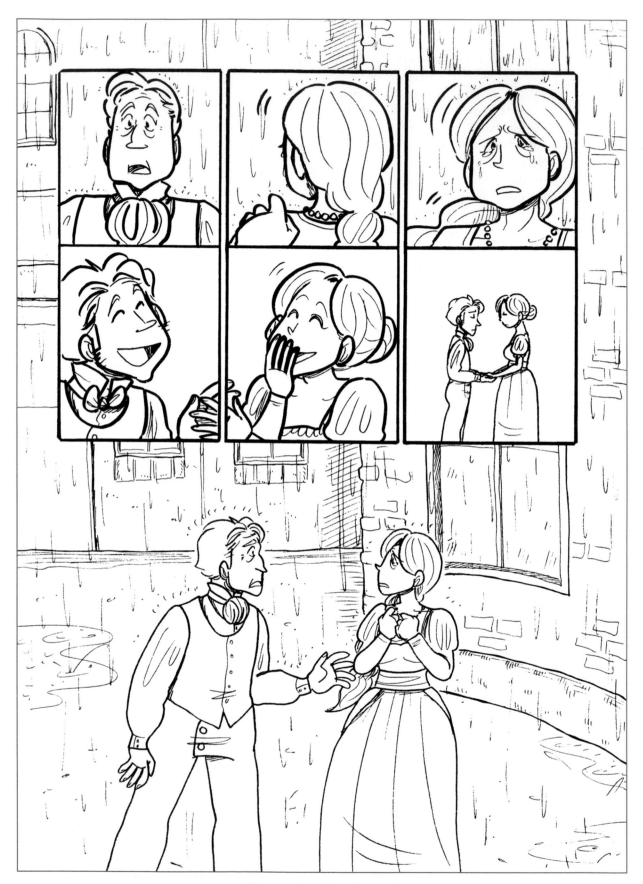

The completed comic page.

An Action Scene

This is the middle of an action sequence: Ivy and Marcus are racing to tackle a problem she has foreseen, but the future does not take kindly to being changed. The first panels are small to encourage rapid reading, while the threatening Future Agent looms without a border to emphasize its size and immediacy. The final panel is also borderless, giving it more impact. This page could be the middle of a story, or it could also work as a first page, throwing the reader into the middle of the action. In that case, the story proper could start on the next page, leaving the cliffhanger of Ivy facing the Future Agent as a sneak preview of the action to encourage the reader to keep going and find out what it's all about. Alternatively, it could be an excellent cliffhanger ending to a chapter.

IVY is racing across a landscape, turning to look behind her. MARCUS is swooping by her head. In front of her, large black shapes rear up, threatening; IVY skids to a stop and stares up at its nearly featureless head. It looms over her.

MARCUS: Ivy! Dream the sword! The Oneiric Blade!

IVY screws up her face in concentration. The sword flares into existence.

Thumbnailed page.

The pencilled page. Note that the text has been rearranged
for a better fit and more dynamic reading.

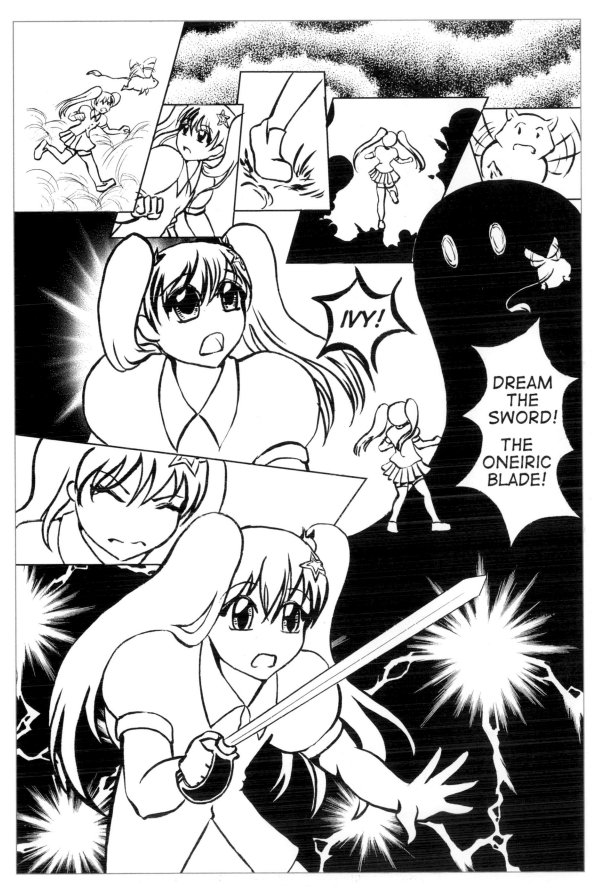

The completed comic page.

A Dramatic Revelation

This page could be both an introduction to Marre and her work and her world, and also offers a hint of her backstory and a promise of action to come. The machine she is working on adds punctuation to the events, as an old friend rushes up to tell her she's in trouble. It could easily be an opening page to the whole story, or perhaps to just a chapter, or it could also be a good cliffhanger as a chapter ending.

Scene: People bustling around industrial buildings.

MARRE: All right, raise it a notch.
APPRENTICE: Yes'm!

The apprentice turns a wheel, and the machine hisses steam.

MARRE looks satisfied, but then there's a loud CLUNK!

MARRE frowns.

MARRE: That didn't sound so good…
Offpanel: No, I need to talk to the senior engineer! Marre!

MARRE turns, surprised. Behind her, the APPRENTICE stares nervously at the shaking, hissing machine.

MARRE: Toby?
APPRENTICE: Er…

TOBY is now visible, standing hands on knees, exhausted. The APPRENTICE jumps back from the machine.

APPRENTICE: Ma'am -
MARRE: Toby, what is it?
TOBY: The army – I heard – they're coming for you.

MARRE is standing before the machine's sudden burst of steam, looking shocked.

TOBY (off-panel): It's about the rebellion.

Thumbnailed page.

The pencilled page. Purple pencil has been used here so the
inked page can be easily cleaned up on the computer.

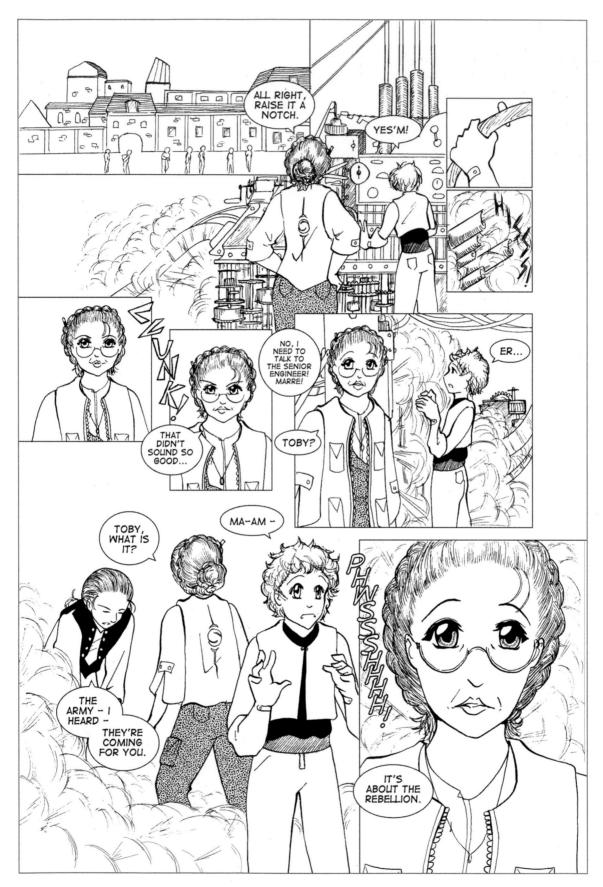

The completed comic page.

Have Fun with your Characters!

Creating characters is great fun, and sometimes they stay with you for many years, giving you inspiration for a multitude of stories. This book is only the first step of a very exciting journey. Good luck!

Keep drawing!

Go for it!

You can do it!

Good luck!

Never give up!

FURTHER INFORMATION

Useful Websites

Blambot.com
www.blambot.com
An excellent source of free and cheap comic fonts with plenty of choice.

Dinkybox
www.dinkybox.co.uk
Retailer of Japanese art materials (among other things), Dinkybox offers a friendly and efficient service.

ImagineFX
www.imaginefx.com/
ImagineFX is a magazine concentrating on digital art. It covers many disciplines and techniques, including those common to manga and anime, and has in-depth tutorials, portfolios and more from well-known artists.

NEO
www.neomag.co.uk
The UK's only magazine focusing on anime, manga, Asian films and Japanese culture, NEO runs a manga tutorial every month.

Sweatdrop.com
www.sweatdrop.com
Home of Sweatdrop Studios, the authors of *Creating Manga Characters*, this website hosts a thriving forum with plenty of advice on and discussion of comic creation. It also has a shop where the comics made by members of the studio can be bought, and a tutorials section covering a range of topics.

Further Reading

Chelsea, David *Perspective!: for comic book artists* (Watson-Guptill, 1997)
This is a highly detailed description of perspective, why it matters and how to apply it, with a focus on comics. Like Scott McCloud's books, it is written in comic form.

Dean, Selina *Drawing Manga* (HarperCollins, 2007)
This is an easy to follow introduction to the basics of drawing in the manga style. Ideal for the first-time artist, it also covers character design and developing storyboards for making comics.

McCloud, Scott *Making Comics: storytelling secrets of comics, manga and graphic novels* (HarperCollins, 2006)
Written in comic form itself, this book covers a vast range of comicking techniques and skills and should be read by every aspiring comic creator. It takes an in-depth look at what makes a comic hang together and the kind of things that need to be considered when telling a story in pictures.

McCloud, Scott *Understanding Comics: the invisible art* (Harper Perennial, 1993)
Also written in comic form, this book dissects the medium, showing how different comics achieve the effects that make them work so well.

Osada, Ryuta *Creating Manga: from design to page* (Crowood, 2010)
This book explains the techniques of manga by analysing some sample pages and discussing the concepts behind the designs, looking in detail at how to create characters, pages and your own distinctive style.

Scott-Baron, Hayden *Digital Manga Techniques: create superb-quality manga artwork on your computer* (A&C Black, 2005)
A comprehensive guide to creating digital images in manga style, this book covers all aspects of art on computers, including scanning, formatting and the most popular software packages. It also contains advice on comic creation and character design.

Sweatdrop Studios *500 Manga Characters* (Ilex, 2007)
This is a royalty-free collection of high resolution manga artwork for you to use. It has a vast range of characters from all genres, provided on a CD as black and white lineart ready to colour.

Sweatdrop Studios, *Draw Manga* (New Holland, 2006)
This is an excellent book covering the basics of drawing in the manga style in detail. It describes the use of different media and includes examples of multiple styles.

Zhou, Joanna *Super-cute Chibis to Draw and Paint* (Search Press Ltd, 2011)
Although this book focuses on the *chibi* style, which it covers in extensive detail with a multitude of excellent examples to learn from, the techniques it describes are applicable to all styles.

INDEX